ACKNOWLEDGEMENTS

The truth is, I did most of this work myself, and after a while, it got to be a chore, but (thank goodness) I did get some much-appreciated help along the way. First of all, thank you to my sweet wife, who is always so supportive and who never criticizes anything. She helped correct my manuscript and gave some good suggestions. Then there was Walter Rolandi, co-founder of the South Carolina Barbeque Association (SCBA), who freely criticized and gave me some remarkably valuable suggestions.

Debby Bloom at the Richland County Public Library is always helpful, as was the whole staff there. Then there was that nice lady—whose name I forget—at the Charleston County Library who kept lugging those heavy boxes out of some dusty back room so that I could work with original materials.

There was also Jackie Hite of Leesville, who is always a hoot to be with and who gave me much insight into barbeque history in his neck of the woods. Also in Leesville, Tommy Shealy of Shealy's Barbeque let us look around and take photos and gave us some good history, as did Jerry Hite of Hite's Barbeque in West Columbia. Pat Clough of Maurice's, who is always so nice and such a pleasure to deal with, was also most helpful.

I've also got to mention Chad Rhoad of The History Press, who listened and showed much patience while I stormed and cussed about the photographs and visuals. They must have hired him for his relentless good humor under fire.

There were a number of people that I talked to on the phone, almost all of whom contributed in some way. The beauty of barbeque is that if you

want to talk about it, you can always get up a conversation on a moment's notice. People love their barbeque.

And then there are the good folks in the SCBA whose photos and quotes were used. The SCBA is about having fun with the world's best food, and the members are always in good humor, which makes for a very genial group of judges. Thanks to all.

INTRODUCTION

The film crew was from *Modern Marvels*, a show that airs on the History Channel, but the activity being filmed was far from modern. In fact, they had asked me to find them a barbeque restaurant where the barbeque was prepared the old-fashioned way. They wanted to show the evolution of that culinary art, and they specifically wanted a restaurant that still made its own charcoal.

We were at Jackie Hite's barbeque restaurant in Leesville, and Jackie, the affable ex-mayor of Leesville and the longtime owner of one of South Carolina's legendary barbeque restaurants, was waxing eloquently about the origin of barbeque. Jackie was in front of his hand-built furnace, in which he burns down hickory wood into coals for his sand-lined pits. The camera was stationed in such a way as to take in both Jackie and the roaring fire behind him. He was not just giving an extemporaneous lecture; rather, he was answering a question posed by the producer of the show as to what he thought the origin of barbeque was.

"Well," Jackie said as the camera rolled, "I was told that once there was a Chinaman who kept his pigs in his house, and one day, his house burned down and the pigs were trapped inside—and that was how barbeque was born."

While Jackie was saying this, I was standing behind the producer and looking directly at Jackie, shaking my head from side to side in an attempt to keep him from saying such a thing on what I knew was to be a nationally televised show. "I don't really know," Jackie continued with a twinkle in his eye, "that's just what I've been told." And then he laughed as if he was

The *Modern Marvels* crew filming the old-fashioned way of making of charcoal at Jackie Hite's restaurant. *Courtesy of the author.*

letting them in on a joke. Sure enough, when the program was aired some six months later, they left that bit of barbeque lore in.

First of all, if a pig had been trapped in a burning building, it would have been a roasted pig, not a barbequed one. And most importantly, it certainly didn't happen in China—the invention of barbeque, that is.

Barbeque is so popular that it, like victory, has one thousand fathers, and many of them have been alluded to on television shows on the Food Channel, the History Channel, PBS and heaven knows how many more that have tried to explore this popular subject. Since television is an insatiable consumer of filmed footage, there are many people—producers, writers, cameramen and others—toiling out in the countryside gathering all the shots they can as they try to put together a show that will have some semblance of fact for America's newfound hunger for reality TV. Often, those shows are rather interesting and informative. But when it comes to the history of barbeque, all of these shows—or at least all I have seen so far, and that is pretty much all that have been aired in the last decade—have struck out when they try to get their facts straight about the origin and history of barbeque. I suspect that the real reason all these sincere souls have failed so badly in getting it right is the fact that most of these TV crews are not Southerners and wouldn't know real barbeque if you hit them in the face with it. And since you can't teach it if you don't know it, most of those on television who are

putting out their message are out of the loop, history wise, and they simply can't, given their educational handicap, present it correctly.

Well, to be fair, a lot of the recent history of barbeque has been pretty good on those shows, especially the ones in which they interview some old-timers in the business who have been around for fifty or sixty years or so and who learned the business at their fathers' knees. And they can certainly do the job on recent developments in the barbeque-sauce business since that business, in a successful nationwide sense, dates back only to the 1940s. But on the subject of the origins of barbeque, the true origin of real barbeque has been remarkably elusive.

Indeed, there is a reason for that elusiveness. As indicated above, the old saying about victory is that it has a thousand fathers, while defeat is an orphan. Since real barbeque is probably the best-loved food in America, it is a "victory" in itself, and everyone wants to claim its invention. Of course, some of those claims are so ludicrous on their very face that they can be easily dismissed—like the fellow I saw on some show who swore that barbeque was first invented in New York City. But some claims, due mostly to the remarkable confusion that exists as to what real barbeque actually is, are not so easily dismissed or even intelligently discussed for that matter.

What I hope to do in the following pages, among other things, is to go over a number of these claims and air the theories that abound and let you see just how easy it is to come to a conclusion as to the origin of America's only indigenous food. To do this, I'll have the pleasure of outlining some of these remarkable theories of barbeque's origin and discussing just why they fail the test. And of course we will be looking at a truly remarkable cultural history that is found only in America and, for the most part, only in the Southern part of America.

I should mention that there are a number of books on the market about the history of barbeque that are quite good. I have several of them on my shelf and have been pleased with the discussion therein in many ways. Indeed, in reading one such book, I told my sweet wife, "Hey, this fellow got all the way to page seven before he made a mistake." At that time, that was something of a record. But I know what he went through, and I sympathize.

One of the problems in trying to document a history of barbeque is that it has not been recorded as well down through the years as one might expect for a subject that is now of so much interest. For a couple of centuries, it rated hardly a mention in the newspapers of the day, primarily, I suspect, not because of any inherent fault of that wonderful food but rather because newspapers were much smaller and more labor-intensive operations. The

newspapers of the 1600s and 1700s devoted themselves to matters more grave than foods.

Indeed, even cookbooks from that period are rare, with recipes being collected and passed on from mother to daughter before they were written down in any collection. The few recipes we have from that early period are really nothing more than those that were collected and put into books that also contained household tips along with instructions for the lady of the house in how to maintain a proper home. South Carolina boasts two from the 1800s that have been re-printed by the University of South Carolina Press. *The Carolina Housewife* by a "Lady of Charleston" (Sarah Rutledge) was published in 1847 and is a proper cookbook, with page after page of recipes. This effort was an outstanding milestone in publishing, as Mrs. Rutledge had put together a book that would become a guide for almost all future cookbooks.

Mrs. Hill's Southern Practical Cookery, first published in 1867, has also been republished by the University of South Carolina Press (1995), and what a dandy it is. This Georgia lady's book is voluminous, and it set the tone and form for most cookbooks that followed. There are over 250 recipes for meat alone in this book, with everything from rabbit, wild fowl and venison to beef in every form you can imagine. It includes recipes for hog's head, pig's feet and instructions on how to roast a whole pig. But there is no mention of how to cook barbeque. What it does have, however, is the first mention of a barbeque sauce that I have found. On page 171, in recipe 335, Mrs. Hill offers "Sauce for Barbecues." This early recipe, plus a few others, have been reproduced in Appendix II for your consideration. Mrs. Hill's wonderful book was, at first, passed off as some "Southern Reconstruction" effort by northern reviewers, but its value was such and its scope so wide that it became one of the most influential cookbooks ever published in the United States.

However, most of the really early cookbooks, as noted, were interesting books that have precious few recipes but lots of advice on canning, herbs, home medicines, cleaning tips and other helpful household hints. And since barbeque was men's work, there is no mention of it in those early books. The very first truly successful recipe book—that is, successful on the national scene—was published in Boston in 1896. Of course I'm talking about the famous *Fannie Farmer Cook Book*, which is still in print today in a revised edition. It is unfortunate that it was Fannie Farmer's book that was so widely read rather than Mrs. Hill's, since Fannie Farmer had an insatiable sweet tooth and put sugar in almost everything. Her influence is still being felt today as

sugar works its insidious way even into Southern cooking in everything from cornbread to collards to modern barbeque sauces.

There are thousands of cookbooks on the market today, but in their present form cookbooks are only a little over 110 years old. And the same can be said for barbeque. It may be everywhere today, but on the restaurant scene and in books and newspapers, any written notice of it is of a much more recent date than its longtime preparation and use would seem to dictate. But the same can also be said of restaurants in general.

Today, restaurants abound in the Western world. I live in a suburb of Columbia, and within two miles of my house, which is situated deep in an area restricted to single-dwelling homes, there are dozens and dozens of restaurants that range from national fast-food chains to mom-and-pop restaurants and diners to takeout coffee stands to everything a person could want, including two one-hundred-mile barbeque houses (that's a restaurant that makes a barbeque so good you would drive one hundred miles to eat it).

This is a new phenomenon. For most of our history, purchasable food prepared outside of the home was for travelers and could be found only in taverns and boardinghouses. Then, in the larger cities, restaurants started to open, primarily in the 1800s. It is a perfect example of something that is so prevalent today that we can hardly even imagine it being otherwise.

Again, barbeque follows this pattern. It was cooked in the home and not sold to the public for the majority of its history. When it was being prepared for the public, it was generally either done as a celebration or to draw people to a speech. Then a few brave souls tried it as a monthly or even weekly preparation, serving it to the public out of meat markets and small covered pits. Later, it was served at takeout stands and even later at sit-down restaurants. As a few of those proved successful, more and more followed. But this natural evolution was slow, and most people did not bother to record its progress. Until today, that is.

As barbeque has become a culinary force in itself, a number of people have tried to capture its historic progress. The pickings among the historical records have been slim, even if the subject is large. Unfortunately, neither my efforts nor the ones I've read are anything close to perfect. Indeed, they only scratch the surface of a subject so wonderful and vast. But bear with us—you'll probably learn something you didn't know, and you'll probably enjoy the trip.

MYTHS, TALES AND MISCONCEPTIONS

Television programs about barbeque always seem to mention that it is a subject of much passion that stirs up many arguments. Thankfully, most of these arguments are of the benign, fun sort, such as, "The barbeque in our area of the state is better than yours," which is sort of like saying, "Our school's football team is better than yours." However, as time has progressed, some of these arguments and differences have actually turned into stubborn dogma. These opinions, sometimes fraught with too much heat and not enough reason or knowledge of history, have given rise to some remarkable misunderstandings. These misunderstandings seem to grow and grow until some of them turn into full-fledged myths. And while barbeque is great fun and most of the disagreements as to whose is the best are part of the fun, there are some real mythologies that need to be sorted out.

In the Introduction, there were a couple of myths touched on briefly, mainly the ones about the poor unfortunate pigs who perished in a Chinese house fire and some misinformed New Yorker who said that barbeque was first tasted in New York. The mention of New York, however, does bring up another myth.

The Pirate Myth

There was a fellow who sent me a long explanation of the origin of barbeque, which he attributed to "pirates" who operated from the Spanish Caribbean in the 1500s. My corresponding friend isn't the only one who saw it that way either, because I had also heard someone on TV say the same thing. Either he got his history from that television show (always a mistake), or they got it from him. Either way, it is in error. But his tale does give us the opportunity to explore what real barbeque is.

Barbeque is pork cooked over very low, indirect heat for a very long time—"low and slow," as the cookers on the barbeque-competition circuit like to say. It also has to be kissed by the airborne marinade of smoke. No smoke, no barbeque. And that is regardless of how tender and juicy and good it may be. Pork cooked slowly in its own juice can be incredibly tender, and depending on the flavor profile that the cook selects, it can also be incredibly delicious. But it's not barbeque.

Another factor is the pork itself. One can barbeque beef, or one can barbeque chicken, goat or almost any meat for that matter, but that meat is barbequed, wherein the word "barbequed" is used as a transitive verb. But "barbeque" is also a noun that describes a specific thing, not an action, and the thing it describes is pork. All proper barbeque is pork. So while one can have barbequed chicken, barbequed beef or even barbequed possum, those meats were "barbequed"; they are not "barbeque."

All this is not simply some modern-day construct; rather, it harkens back to the first real barbeque, which was pork. This is a matter that we will go into in the next chapter, when we get on to the actual invention of America's favorite food.

But speaking of semantics, the word "barbeque" is often used incorrectly as a noun, as in, "Almost every American home has a barbecue." That quote was taken directly from a cable television show called "Food Wars—Barbecue" that was shown on the Travel Channel. In that instance, a grill is mistakenly called a "barbecue." In fact, on the barbeque-cooking circuit, where weekend barbeque warriors battle it out for trophies and cash prizes, they never refer to their grill as a barbeque. They always call it a cooker, a smoker or a grill.

But back to the myth about the Caribbean pirates.

My friend explained to me that the pirates learned barbequing from the Indians on the Caribbean Islands and took it from there to all of the

places they then went (he probably saw that on television). Those places still practice true, original barbequing to this day, according to him. "I've seen it with my own eyes," he told me. "Why, in northern Mexico, I've seen them dig a hole in the ground and put a goat in it, cover it up and then several hours later dig it up…then you've got some of the best barbeque you've ever tasted." He continued by telling me that wherever pirates went, one can still find real barbeque today as a living heritage from its original introduction.

Well, let's take a look at that myth. First of all, there were plenty of pirates in New England and New York, not to mention England, France and Spain, but there was no barbeque in those places, so it just isn't true that barbeque followed the pirates.

The Roasting Box Myth

The real problem with the pirate myth, however, is the cooking method described. Digging a hole in the ground and filling it with coals or hot rocks and covering it up with either dirt or leaves or some other cover is not only eons old but also worldwide. Aborigines in Australia did it. Africans in Africa did it. Asians and Indians did it. And all of them have done it forever. In fact, we still do it today in the form of clambakes and oyster roasts. Dig the hole, put the coals in, put the oysters or clams on the coals and cover them up, usually with a wet burlap bag, and have a beer. Since oysters and clams cook quickly, by the end of your second beer, you've got a party going.

But you didn't call it a clam barbeque or an oyster barbeque. That is because even though they were thoroughly cooked (in actuality, steamed), they were not barbequed. By the same token, putting a pig in the ground over coals and covering it doesn't make for barbeque. It makes roast pig. And if it's done right, it's a tender, juicy roast pig, but it is not barbeque. There are various apparatus on the market today that do just that. They are called "Cajun microwaves" on the barbeque-cooking circuit but are more properly known as roasting boxes. The term "Cajun microwave" has become so common that there are several companies on the Internet that offer them by that name.

The reason that roasting boxes are a great way to cook pork and other meats is that because the meat cooks in its own juices, the end product is always quite tender and juicy. But it is not barbeque, and the people

who make those roasting boxes know enough not to call them "barbeque boxes"—which is more than my friend with the pirate theory knew.

The First Indians Myth

When the Spanish first came into the Caribbean in the 1490s, they discovered various Indians who were cooking in holes in the ground. This was not unique since that method of cooking was used, to some degree, worldwide. Every culture had discovered it.

The poor Indians on the islands generally found themselves enslaved by the Spanish and made to do the work, and that work included cooking. The Spanish soldiers and sailors were thereby reintroduced to that age-old method, and they carried the knowledge with them as they came ashore in the Americas. They, like the "pirates," carried that simple method everywhere they went. As I say, this was all well and good, but meat cooked in a covered hole is not barbeque.

There has been quite a bit of speculation as to where the word "barbeque" actually comes from. Whether it is true or not, most writers today give a nod in the direction of the Taíno Indians, who Christopher Columbus encountered in 1492. Given what happened to the Taíno, they probably get the credit for barbeque simply because Columbus saw them first and was so happy to see them and impressed by them that he heaped praise all over them in his dispatches back home. That first meeting with the Taíno also gave up the word "barbacot."

Columbus landed on what he named Hispaniola, which is the large island that today we call Dominica and which contains the two countries of the Dominican Republic and Haiti. The Taíno were described by Columbus as a wonderful, gentle, happy, friendly people who gave him great aid. Unfortunately for the Taíno, they were the blood enemies of the Carib Indians, whom everyone described as fierce, warlike, cannibalistic and sadistic and who were adept at making poison arrows.

While Columbus did not take a census, rough estimates of the Taíno population range from twenty thousand to fifty thousand. The Taíno were a numerous people that occupied other islands in addition to Hispaniola, including Cuba, Puerto Rico and Jamaica. They spoke a language that the linguists say is similar to Arawak, so they were probably Arawakan, a word that often pops up when people are talking about the origins of barbeque.

By the outbreak of the first smallpox epidemic in 1518, a scant twenty-six years after Columbus's arrival, the poor Taíno had already suffered defeat and enslavement by the Caribs. That coupled with white man's diseases had reduced their numbers to just a few thousand by 1515, when somebody took note. In 1544, a bishop on the island of Puerto Rico placed their number there at no more than sixty. Although modern DNA tests show that Taíno blood lives on in mestizo populations, war, slavery, intermarriage with whites and disease had finished them off by the mid-1500s.

However, the Taíno did leave behind some cultural heritage. Their words "hamaca," "tobac" and "huracan," for instance, give us "hammock," "tobacco" and "hurricane," respectively. Other Taíno words that are still with us include "iguana" and "yucca."

Then there is the Taíno word "barbacot," which is generally considered the root word for "barbeque." That word has caused a great deal of misinformation to be circulated and has caused many people to assume that barbeque was a Taíno food.

A "barbacot" is a structure of green sticks that the Indians used in roasting small meats. The only Caribbean example that I have seen of this kind of structure comes from an old drawing that depicts a simple, slanted stick, on which the meat roasts over the fire, supported by another forked stick. It was reminiscent of the sort of apparatus a Boy Scout might make. The more elaborate structure that is generally called a "barbacot" today is seen in the drawings of Jacques le Moyne, a Frenchman who made his drawings in North America, not in the Caribbean Islands.

One of the problems with barbeque originating in the Taíno world is that, for the most part, there were no large animals on those islands when Columbus arrived. *El Boricua*, a monthly cultural publication for Puerto Ricans, has a reasonably complete discussion of the Taíno. The magazine writes, "Not much hunting went on because there was no large game. However, the Taínos did hunt for birds, manatees, snakes, parrots, jutías (small rodents), iguanas, and waterfowl."

The Taíno diet consisted primarily of fruits and vegetables, as those foods were abundant on the islands where they lived. Occasionally, they ate fish, shellfish and other small game. As *El Boricua* notes:

> *Yuca was the Taíno staple food, and from it, flour and casava bread were made. The Taínos primarily used tubers as a source of food. Also harvested were guanábana, yautía, squash, mamey, papaya, pineapple, achiote, sweet potatoes, yams, and corn. Peanuts, lerenes, guava, soursop, pineapples, sea*

grapes, black-eyed peas, ajíes caballeros, and lima beans grew wild. They would also crush roots and stems of a poisonous shrub and cast it into the rivers. As the fish became stunned by the poison, they could be caught by hand; the poison did not affect the fish for eating. The men also harvested conch, oysters, crabs, and other shellfish.

The Taíno simply did not have any animals of any size that needed barbequing. Roasting a parrot or a rodent is quite sufficient to get it cooked. It was the Spanish who brought domesticated horses, goats, sheep, cows and pigs. These animals are all old-world animals, and they simply did not exist anywhere in the western hemisphere. Well, actually, wild goats and sheep did exist in the Western part of the Americas, but they were never domesticated. There were no goats or sheep on the Caribbean Islands.

One of the problems in this area of myths and misunderstandings is that people who know nothing about the subject will say in some book or on some television show, "Here we see a picture of meat being barbequed by an Arawak Indian," when what they should more properly say is, "Here is a drawing of someone cooking meat over an open flame." The problem then becomes that the reader or viewer, thinking he is getting some real history, will stash that thought away in his mind and later share it.

Another problem that we face when trying to delve into the origins of barbeque is the word itself. As mentioned above, some think "barbeque" is a Taíno word, but that is because of the word "barbacot," which probably evolved into the word "barbeque" much later.

I once saw a program on some cable channel that showed a nice Indian-looking young lady who was being touted as a "princess" or a "priestess," I forget which. She was addressing the camera with a big smile on her face while gliding around in a nicely manicured backyard somewhere in Miami, Florida. She was demonstrating that the "Sacred Fire" of her tribe, which I'm most sure she said was Arawak, was a godly and holy thing. I was obviously missing lots of the details, but the thing that I'm 100 percent positive of is that what she was showing was a roasting box. In fact, I pointed it out to my sweet wife and said, "That's what the boys on the cooking circuit call a 'Cajun microwave.'" Of course, this comely young lady was talking about barbeque, often using that word and saying how barbeque was sacred to her people. That was all well and good, except for the fact that a roasting box produces roast pork, not barbeque, and that she was using the word "barbeque" incorrectly.

This problem with the word "barbeque" is one that all of us are at least vaguely aware.

When a South Carolinian uses the word, he means pork cooked slowly at a low temperature over coals. When a Texan says it, he generally means beef. When a northerner says it, he means a grill or a cookout in the backyard. And when Paul Hogan, the Australian movie star who played Crocodile Dundee, said it on those famous TV ads, he meant the apparatus on which he put a giant prawn, which he facetiously called a shrimp. Apparently, when that young lady who was talking about the Sacred Fire of her people said barbeque, she meant meat roasted in an enclosure built for that specific purpose. In short, the word "barbeque" can have entirely different meanings in different places. So the use of the word "barbacot" in Dominica, even if it was truly a barbecuing structure (which I've seen no evidence to support), does not mean that real barbeque was invented there.

The Origin of the Word Myth

This misunderstanding of the word used to describe barbeque has led to all sorts of speculation and conjecture regarding its origin. One oft-repeated tale is that it derives from the French phrase "barbe à la queue," which supposedly means "from beard to the tail." However, I have my doubts about this tale. Heaven knows the French certainly know their food, but barbeque isn't one of them. Plus, the French were not poking around in the Caribbean when the Spanish were there.

Indeed, the French, who were also looking for colonies in the 1500s, entered the waters of America generally from the north, trying to avoid the Spanish, who would open fire on them at first sight. It was a wise choice for the French, who finally decided to stick close to the American middle, along the Mississippi Valley, where we find New Orleans, Mobile, Dubuque, Des Moines, St. Louis, Sault St. Marie, Quebec and many other remnants of French sites still proudly sporting their French names. For the most part, after 1566, the French left the East Coast of the Americas to the English, and they left the Caribbean to the Spanish. They certainly were not sitting around eating and talking with any Arawaks in the Caribbean, although they did meet plenty of Indians in Florida when they first boated down there to look for colonization opportunities.

Writers today give more credence to the idea that the word "barbeque" derives from the word "barbacoa." Wikipedia, the world's most used and most incorrect encyclopedia, states, "barbacoa is a form of cooking meat that originated in the Caribbean with the Taíno people, from which the term 'barbecue' derives." This submission from heaven knows who (anybody can submit anything to Wikipedia, and if it isn't challenged or corrected, then it stays in) is probably the generally accepted origin of the word. It brings to mind Napoleon's observation: "History is the lies that are agreed upon."

Indeed, the next sentence in that same Wikipedia article goes on to say, "In contemporary Mexico, it generally refers to meats or whole sheep slow-cooked over an open fire, or more traditionally, in a hole dug in the ground covered with maguey leaves, although the interpretation is loose, and in the present day and in some cases may refer to meat steamed until tender." Well, that little bit of a dog's-breakfast definition happily contains some obvious red flags. For one, the Taíno didn't actually use the word "barbeque" but rather "barbacot," which referred to a structure, not a food. Secondly, they didn't have any large animals to "steam." And lastly, the hole in the ground is a steaming technique, not a barbequing technique.

The First Barbeque Restaurant Myth

On at least three different TV shows, I've heard the narrator say (and this is an approximation), "It is generally agreed that barbeque was first invented in North Carolina, as it was home to the first barbeque restaurant." Well, it may very well be that the first real sit-down barbeque restaurant was in North Carolina, at least the first successful one.

Back in the 1700s and 1800s, the courthouses in the South (and everywhere else for that matter), along with churches, were often the only places where locals could hold meetings. In other words, courthouses served as both the community meeting hall and the place where justice was handed out. In fact, the courthouse was generally used for legal matters only one or two days a month. The judges in those days were traveling judges, going from town to town, and that tradition lives on in the term "circuit court."

Since court day was a big event in rural areas, families would come from miles around to go into town. Often, the ladies would do their shopping while

the men were over at the courthouse attending to business or, more likely, watching whatever trial was going on. After all, everybody knew everybody in these communities, so any legal event was everybody's business.

These remarkably small towns may have contained nothing more than one courthouse, one church, one small rooming house, one general mercantile store and a few houses. There simply was not enough human traffic to support a restaurant. Nevertheless, people in town for court day got hungry. Most took the obvious precaution of bringing along basket foods to eat, but there was an alternative being born, the first "fast food." Some enterprising men would cook barbeque the day before court day and bring it to town in a wagon. Since barbequing meat, especially when cooked with a vinegar basting sauce, allows it to be stored for a couple of days longer than uncooked meat, they could cook it up a day sooner than it was being sold. These enterprising men would come to town, drop the tailgate on their wagons and sell to the locals the barbeque they had cooked along with the bread their wives had made. Some of this barbeque was quite good and earned the seller a good reputation and a loyal local following. Court day became the day when people most often ate barbeque. Thus, barbeque came to be associated with court day (and later, political rallies) and other important events.

At some point, these husband-and-wife cooking teams found that there was enough foot traffic in these small but growing towns to support a small eating establishment. When that happened, the barbeque stand was born. And even though it took a while, the barbeque stand eventually evolved into the barbeque restaurant.

It is said that the first sit-down restaurant was established in North Carolina. Maybe so. But given the vast number of new counties being formed all over the new nation, plus the climbing frequency of court days, it may very well be that there were other "restaurants" that were opened in various states but closed a year or two later, completely lost to history. However, just because one area has the "first barbeque restaurant" does not mean that barbeque was invented in that same area. When the subject comes up at various seminars, I always ask the members of the audience to hold up their hands if they think that waffles were invented in Atlanta, Georgia, in 1955. No hand has ever gone up. That is because waffles predate 1955 by generations and were being eaten in Europe before Atlanta was even a train terminal, much less a town. But the first waffle restaurant was, indeed, opened in Atlanta in 1955. The ubiquitous Waffle House that we see at every Interstate juncture in the American South came on the scene

in Atlanta in 1955. Yet no one, not even New York TV producers, think waffles were invented there. But they will blithely say that barbeque was first invented in North Carolina because someone else said that the first barbeque restaurant was located there. As you can plainly see, that logic does not hold.

The Barbeque Was Invented in North Carolina Myth

This myth is actually slightly different from the previous myth. In truth, North Carolina, a state dear to my heart, a state that turns out some of the best barbeque in the nation, is probably a latecomer to the barbeque scene—that is, the really early barbeque scene.

On the "Barbeque" episode of the History Channel's *America Eats* show, the narrator said, "The explorers brought it [barbeque] back to the colonies, where it did particularly well in the area of North Carolina, which is generally regarded as the birthplace of American barbeque." As I've mentioned before, this is a widespread myth among New York and California television producers and writers.

The real problem with that statement is that those "explorers" the narrator was referring to were Spanish, and the Spanish seldom ventured above Cape Fear, which is about the dividing line between today's North and South Carolina. Indeed, when barbeque was actually invented, there was no North and South Carolina; there was only Spanish La Florida.

In the mid-1500s, the English had not settled in the area of North Carolina yet, and when they tried it (in 1585), it didn't go well, as the name "Lost Colony of Roanoke" attests. When the English did plant a lasting colony in America, it was in Virginia at Jamestowne on the James River in 1607. The small triangular fort the settlers built there had one of its cannons facing down the James River, just in case the Spanish were to come. They never did.

It turns out that by that time, the Spanish and the English had long since grown tired of shooting at each other in the undeclared Anglo-Spanish War of 1585 to 1604. Although that was an "undeclared" war, it was actually acknowledged by both sides and was settled by a written treaty in 1604. So after 1604, the English and Spanish decided to go about their business of settling colonies in the New World rather than sinking

each other's ships. But you can see from the treaty date why the people in Jamestowne might be a bit nervous; their settlement was established only three years after the official hostilities had ended. Plus, they were sure they couldn't trust a Spaniard, anyway.

But the Spanish had other fish to fry, mainly getting as much gold out of Central and South America as they could. And now that the English had promised not to shoot at their ships anymore, the Spanish honored the treaty by restricting their activities to the area they had already claimed as their own, which included present-day Florida, Georgia, South Carolina and even Mississippi. The Spanish considered this area to be theirs, and they called it La Florida. They were careful not to venture into the waters of today's North Carolina. Besides, going up the North Carolina coast along the Outer Banks was remarkably dangerous even if no one was shooting at you. That area isn't called the "Graveyard of the Atlantic" for nothing.

And it's true that some Spanish explorers, such as Hernando De Soto (of whom you've probably heard) and Juan Pardo (of whom you've probably never heard) made it into what today is North Carolina on foot, but those expeditions, like the one Cortez sent into northern Mexico, were in search of gold and silver and anything else that they could easily exploit; they were just passing through. Indeed they were always hurrying along because time was money, and money was what it was all about. For instance, Hernando Cortez, at his death, was probably the richest man in all of Europe, richer than most kings. He was the equivalent of a multibillionaire in today's world. Cortez's shining example was before the eyes of every Spanish explorer who was out beating every bush in this newfound land.

Since almost everybody, educated or not, recognizes that the Spanish and the Indians were the co-inventers of barbeque, then North Carolina is absolutely ruled out as its birthplace, as no Spanish were there except those visiting the western part of the state—and they were hurrying along to get to what they were really looking for. They certainly did not establish any settlements in North Carolina other than the handful of men Juan Pardo left in the mountains to keep an eye on the Indians. (And even those men left in a about a year and headed back to Santa Elena.) Those few men who were left alive in the wilds of North Carolina were happy to get out of the mountains and back to the more easily traversed flatter lands of north Georgia. No barbeque for them.

So, despite the TV myth of North Carolina being the home of barbeque, it just isn't true.

The Blacks Invented Barbeque Myth

There is another widespread misunderstanding about barbeque in America that is so pervasive it has taken on the statue of a full-blown myth. That myth is that Southern blacks invented barbeque, and we have all heard that myth so many times that one wonders if it can ever be corrected.

The origin of the myth is simple. Southern blacks worked on the plantations and did almost all of the heavy lifting. That means they learned to cook barbeque in the same way they learned to become cabinetmakers or blacksmiths: somebody needed the job done and showed them how to do it. Since food is loved by all and many blacks are naturally good cooks, they took to the art of barbeque quickly and well.

Then, in the early part of the twentieth century, International Harvester bought up some patents of a horse-drawn cotton picker, hooked it up to an internal combustion engine and brought out the first successful mechanical cotton picker. This single invention replaced the necessity of thousands of field hands on the cotton fields in the South. Over the next few years and all the way up to World War II, unemployed blacks left the South in droves and went north to find jobs in factories. They took their knowledge of how to cook barbeque with them. Once in the north, they cooked barbeque for themselves, and the white northerners slowly began to seek it out in the small black-owned cafés that served the black community. Northerners who had no history of barbeque in the early twentieth century and really no real notion of it were mesmerized by this succulent new eating experience. Soon, thousands of northerners were eating real barbeque for the first time. Northern food critics writing for the local newspapers discovered barbeque and wrote it up in glowing terms. Magazine articles started coming forth in praise of this "new" food.

The problem was that all northern writers saw barbeque as a black food because every time they got their hands on some it had come from black cooks. Barbeque became linked to blacks in the minds of northern writers. After all, they had seen it with their own eyes. It's true that blacks were selling barbeque in the North, but in the South, blacks were still generally relegated to the status of helper unless they owned a small café in a black community. Blacks were certainly not the inventor of barbeque—a fact lost to northern writers, who neither knew nor, given their general ignorance of any history

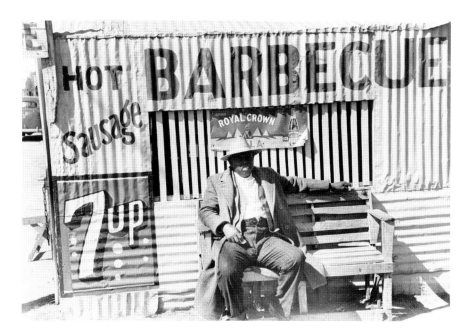

Blacks set up small restaurants in northern cities to serve their communities. These eateries were soon discovered by northerners, who came to associate barbeque with southern African Americans. *Library of Congress.*

of the South, were ever able to figure out. That misunderstanding got coupled with another interesting fact so much so that it, too, took on the status of a myth.

THE MISUNDERSTANDING OF THE LESSER PARTS

The Kansas City Barbecue Society (KCBS) is the largest trainer of Certified Barbecue Judges in America. I am a certified KCBS-trained judge as well as a Certified Memphis Barbecue Network judge. In taking the KCBS seminar, I was horrified to see a short film shown to all of the new judges that perpetuated a remarkable misunderstanding of the origin of barbeque coupled with the misunderstanding of the role blacks played in the development of Southern foods. In that KCBS seminar film, they talk of slaves being given the "lesser and tougher" cuts of meat for their personal

use at slaughtering time. They then go on to say that blacks learned to cook these tougher cuts of meat by cooking them low and slow and that that was how barbeque was born.

There are several problems with these theories, the most obvious being that pork, as opposed to beef, doesn't really have any tough parts. The hams are about as tough as the shoulder, and the ribs are just about as tough as everything else.

Kansas City, Kansas, which abuts Kansas City, Missouri, the home of the KCBS, is truly famous for its beef. What the KCBS was confusing when they talked of barbeque is that part of the cow called the brisket. Beef, like pork, does have some less desirable cuts, and on a cow, that cut is the brisket. The brisket is the tough muscle that comes across the front of the cow between the front legs. A grilled brisket is virtually inedible. A tender, edible brisket has to be either boiled and then braised or barbequed.

It may be that blacks out west were regularly given the beef brisket in the 1800s and early 1900s and that they used their barbequing skills to make it edible, but that is not what happened to the lesser parts of the pig in the South. On the pig, the less desirable parts are the intestines, called chitterlings (or chitlins to real southerners); the head (and brain); and the feet. Blacks learned to make delicacies of all of those parts. But those parts did not need to be barbequed, because except for the feet, which were boiled and pickled, they were not tough.

So here we have the KCBS showing a film to thousands (it claims to have certified over twelve thousand judges) of people in which it presents misinformation and myth as fact. In other words, it had made the same mistake in attribution of the invention of barbeque to blacks that northerners made, but for different reasons. Blacks didn't invent barbeque. It just so happens that some of them, like some of their white fellow southerners, cook it very well, but invent it they did not.

Another problem with the Texas-Kansas City axis is that both of those areas are latecomers to the barbeque scene.

It's true that the Spanish conquistador Hernando Cortez sent scouting parties from his central base in what is now Mexico City into the north of Mexico, which is now Texas. But those scouting parties were looking for gold, not indigenous cuisine. They went through the area that became Texas as early as 1522 (Cortez having landed in Mexico in 1519), but they were just passing through in search of El Dorado. Given the hostile attitude of most of the Indian tribes they encountered, they were surely moving along at a good clip.

Real barbeque in Texas came along long after the conquest of Mexico, but it was brought in by settlers primarily from the South, mostly after Texas declared its independence from Mexico in 1836. There were probably fifty thousand "Anglos" (as they were called by the Mexicans) in northern Mexico before 1836 when they declared their independence from Mexico. Most of these Anglos were from the South, so many of those southerners, both black and white, had to have been cooking some real barbeque in Texas even before it was Texas. But those settlers came in the 1800s, not the 1500s, which as we will see, is when barbeque was invented.

Texas may have some great barbeque, and it definitely has the best barbequed beef, but it is not the birthplace of barbeque.

THE MYTH OF THE FIRST MENTION

There is another myth stemming from a failure of logic and reason that often pops up. After Darwin published his *On the Origin of Species* in 1859, scientists began talk of a "missing link" between modern man and lower primates from which we had descended. This was a raging controversy, and it set the archeologists, paleontologists, zoologists and others in the scientific community on a quest to find this link. Every time a new set of humanoid bones was found, the newspapers would declare, "The Missing Link Has Been Found!" Actually, all that had been found were more bones of another early primate, because as scientists came to realize about a century later, there was no missing link at all. All of human evolution had been more of a vast web rather than a single chain that stretched from the present to the past.

A more recent example of the first-found misconception is Neanderthal Man. As almost everyone knows by now, the first Neanderthal bones were found in the Neander Valley in Germany near the city of Düsseldorf. That find is so ingrained in our consciousness that every show on TV depicts Neanderthals tromping around in northern Europe in the snow. However, thanks to more recent discoveries, we know that Neanderthals were scattered west from central Asia south to Palestine and over to Spain. In fact, more remains have been found in the south in Yugoslavia, Turkey and Israel than anywhere else. Yet the Neanderthal is firmly fixed in our collective minds as being from Germany, since that is where it was first discovered.

The same has happened with barbeque. The first mention of real barbeque in our country's history occurs in a Virginia law passed in the 1690s. There, the House of Burgesses passed a law stating that firearms were not allowed at barbeques. Obviously, barbeques had been going on in Virginia long enough for a pattern to have evolved, one in which people got together in large numbers, with at least one person getting drunk and shooting someone either accidentally or on purpose. Some historians, however, having found the first mention of barbeque in the laws of Virginia, then proclaim that barbeque was invented there.

In 1986, there was a law passed by the South Carolina legislature that stated that a barbeque restaurant had to put a sign on its front window telling its customers whether or not it used a wood fire or some other form of heat to cook its meat. This was an attempt, obviously, of the South Carolina legislature to protect the unwary consumer from eating ersatz barbeque cooked over electric cookers. In truth, the law has been ignored, and I've never seen such a sign. But since the South Carolina legislature passed that law in 1986, does that mean that was the first time barbeque was cooked using wood or electricity? It was the first time a law was passed mentioning wood and electricity, so it falls into the same category as the first mention of barbeque in Virginia.

There are other myths and misunderstandings out there, but that's enough for now. I'll leave you to apply a bit of reason and logic to them as you hear them.

So where did real barbeque come from? Let's tackle that in the next chapter.

BARBEQUE IN THE BEGINNING

Barbeque—real barbeque—is the gift of two civilizations. It was the Indians' way of cooking meats slowly so as to make tough meats tender combined with the pig that the Spanish introduced into the western hemisphere.

It appears that Indians had hit upon barbeque probably by happy accident. There are several things that we can do with smoke and fire when it comes to cooking. The one everyone seems to know is what we call "smoking"; that is, putting meat over a smoking fire until the smoke permeates the meat. That smoking process also helps preserve the meat for a long period of time and, depending on the type of wood, also lends an excellent taste.

Some meats, such as fish, are easily smoked. Many different Indian tribes all over the American continents had long since learned that smoking fish would preserve it. Today, various Indian tribes out in the Northwest all the way up through Alaska smoke fish by the ton each year for their own use, as well as for commercial sale.

When I was young and my grandparents on my mother's side were still farming, they had a smokehouse. What a dark and wonderful place that was for a young boy! I would open the door and peer in, taking in those delightful smells as I made out the darkened hams that were hanging there. Almost every farm had a smokehouse in those days. Most of them dated from the 1950s, when I was learning about them, all the way back to the first colonies in the New World.

A smokehouse is about smoke, however, not barbeque. In a smokehouse, there is lots of smoke and not much heat. The fires are kept very low and

built in such a way as to give off maximum smoke with very little heat. The object is to smoke the meat, not cook it. Roasting, on the other hand, is when the fire is built so as to give off maximum heat without that much smoke, allowing the meat to cook quickly.

The Indians had discovered the cooking method of barbequing, which lies between those two cooking styles. They discovered that less fire than roasting but more fire than smoking gave them a slower way to cook, the end product being more tender and juicy. Anyone who has eaten venison roasted and then barbequed will appreciate having that tough meat barbequed.

So, the Indians had the method, but they didn't have any readily available meat source other than deer that was truly optimal for barbequing, and in the Caribbean, they didn't have even those. It's true that they had raccoons and dogs, but those animals lent themselves better to roasting. The real problem with Indian barbeque is that they didn't have the pig. Enter the Spanish.

A Little Local Spanish History

Domesticated horses, cows, sheep, goats and pigs were all brought by the Spanish. In return, Europe received peppers (true capsaicin peppers, not "black pepper," as we call it), pineapples, tomatoes and the potato, which was first known in Europe as the Spanish potato before it generally became known as the Irish potato. In those culinary swaps Europe got mostly vegetables and the Americans got pack animals and meat animals.

It just so happens that pigs are wonderful animals. In present-day Europe, pork is the major meat, as it has been for hundreds of years. They may eat a lot of mutton in Australia and Scotland, and we may eat lots of beef in the United States, but for most of the time we have been in America, pork was the major meat source. It's hard to imagine breakfast without the pig as we help ourselves to bacon, sausage or ham to go with our biscuits, grits and eggs. The same goes for supper. Where would we be without pork loin, ham, pork chops or sausages?

One of the beauties of the pig is that it has a very short gestation period of about 114 days, or the easy-to-remember three months, three weeks and three days. A mother pig will breed about twice each year, and she will birth anywhere from eight to twelve piglets per delivery. In all, a female pig will produce about twenty or more piglets per year. With some of those piglets

not being eaten and living to maturity (which for a pig is less than a year), a farmer, given the natural fecundity of the pig, can be covered up in pork in a few years.

A cow, on the other hand, has only one calf each year, and if she lives to be ten years old, she will produce only about seven calves. This low birth rate for cows meant that cows were kept around for what they produced rather than as a meat source. Their milk was very useful in cooking and eating, plus milk was indispensable with babies. Butter was also absolutely essential, as Crisco hadn't been invented yet, so a cow was much prized and protected. A farmer might have, if he were prosperous and lucky, two cows, but a careful farmer could have his pigs just keep on multiplying almost as fast as he could eat them.

Pigs are also quite easy to raise. They will eat almost anything, and if the farmer doesn't have any leftovers to feed them ("slop the hogs"), pigs will root around in the woods for their own meals. Pigs are reasonably gregarious and territorial, so while they were given to running off in search of something to eat, they had a tendency to come back to the herd and to stick around.

Every Spanish expedition had its swine herder, just as it had men whose job it was to handle the horses. They had to have the horses to carry supplies and to serve as instruments of war, but they had to have the pigs to survive so the swine herders were quite valuable. These expeditions were quite an expensive undertaking. The king, who generally financed the expeditions, was to get a percentage of the take. To this end, he sent along a couple of scribes to write down everything that happened in a daily log. Some of these scribes, such as Alvar Nunez Cabeza de Vaca, became famous in their own right because they kept such good records and survived to tell their tales. Nevertheless, each expedition was recorded so that the king would get what was rightfully his share of the loot.

These expeditions had leaders, soldiers, many divisions of laborers and even scientists and artists, mostly naturalists, who where supposed to note and draw any new plants and animals they found. If gold was not in the offing, and it generally wasn't, there was money to be had in the spice trade. Cinnamon was much prized, and ginger was also valuable. It was the spice trade, not gold, that made most European merchants into the rich men they became. Even lowly tar and lumber could be converted into treasure for the new conquistadors. In short, these were not willy-nilly undertakings. Big money was invested, lives were lost and fortunes were made. The successful were covered in glory and riches, and every man who survived got a share of the take, depending on his status and the labor he contributed.

If an expedition was a success, the share even the lowliest man got could vault an illiterate, lower-class man into the upper middle class when he arrived back in Spain. If a laborer survived a successful expedition, he could retire to a happy middle-class life and never have to work again. This was the incentive that kept the ships' holes full of men willing to travel to a new land. All of this took many years, and while some expeditions yielded great wealth, most were fraught with danger and loss of life. A better way had to be found, by the king at least, to get the same results without such a continuing outlay of funds. The solution was colonization.

The first eighty or so years of Spanish conquest in the Americas were headed by explorers and conquistadores, as we call them, men who led large operations designed to conquer and hold land and then take the riches that land would yield. A colony, on the other hand, did not need such a large military presence over a long period of time if it could be situated in an area mostly away from European enemies and where the natives were either non-existent or, better yet, friendly. Friendly natives could be very useful in helping these newcomers explore and showing them the local ropes, so to speak. Often, a local tribe might help defend a colony from some of the not-so-friendly tribes of Indians who invariably lived not too far away.

The Spanish had been trying to establish a lasting colony in La Florida since 1521. They had sent out efforts into what are now the Tampa Bay and Jacksonville areas in Florida, the Winyah Bay and Port Royal areas of South Carolina and a few other locations. None of them lasted over a year. Some lasted all of two months before the settlers gave up. The Spanish, it seems, did not understand the hurricane season and were always losing ships in storms. They also failed to grasp that Indians didn't want to be slaves, finding them to be, for the most part, hostile. The problems of logistics and supply were vexing, and just how hard it was to set up a new town with hundreds of people in it escaped them at first. Regardless of all of their good intentions from 1521 to 1564, nothing the Spanish did in the area of today's Florida, Georgia and South Carolina had any permanency.

A Little Local French History

The French had, in the early 1500s, been poking around down the Atlantic coastline all the way to below what is now Saint Augustine. Spain's King Philip

The talented artist Jacques La Moyne accompanied Jean Ribault on his first explorations and made the only drawings we have of the 1500s land and natives. Ribault and La Moyne sailed into Port Royal in 1562. *Wisconsin Historical Society*.

II (he wasn't called "Philip the Prudent" for nothing) decided that the best way to keep the French from overrunning his La Florida was to set up a thriving colony there and use that as a base for future activity. The immediate problem for Phillip was that in 1562, the French, under the leadership of Jean Ribault, had built a fort in the northern part of La Florida in the area that is modern-day Port Royal, South Carolina, where Parris Island is today. They named it Charlesfort for the French king Charles IX. Jean Ribault, a Huguenot, had even sailed farther south than modern-day Saint Augustine in search of colonization opportunities, and the Spanish were keenly aware of it.

The operation back at Charlesfort on Parris Island, however, was not going well for the French.

First of all, while it is true that Ribault was looking for colonization opportunities for a Huguenot colony, his expedition in Port Royal was not a real colonization effort but rather a quasi-military exploration operation,

meaning that the French had lots of soldiers and sailors on their ships but no women. And it didn't take long for the Frenchmen to aggravate the Indian men by chasing the Indian women around.

Even though they had set up a fort, Ribault wasn't completely happy with the area. He was interested in making explorations to find a better location farther down the coast toward what today is mid Florida. Plus, if they were to make a go of it in Port Royal, he needed more men and supplies. So Ribault left only twenty-eight men at Port Royal and went back to Europe to get what he needed.

The few men Ribault left behind were not very good at farming. To farm successfully in a new land where the soil is different from back home is a real challenge. The soil at Parris Island was not only different from back home but it was also sandy and poor. Farming there was simply not a workable situation for so few Europeans who were not real farmers.

The French plan was to mooch as much food from the Indians as possible and trade iron and steel implements such as knives and axes for the rest. The problem with that plan is that most of the Indians who were in the Port Royal area were primarily hunter-gatherers rather than farmers. Of course, the Indians did have small patches of corn, pumpkins, squash and beans, but they didn't build up large stores of food to carry them through the winter. They stored what they needed, but not a lot extra. So after the chief got some nice new knives and a few axes were passed around to eager and grateful Indians, there came a time when the Indians realized that there wasn't enough food to give the French any more without going hungry themselves. After all, you can't eat an axe.

At that point, the French were starving, and they became more insistent on Indian aid. The Indians simply refused, and there was lots of parlaying, leading to some pushing and shoving that, unfortunately, led to a few shots being fired. After that, the Indians simply disappeared into the woods, and the French were left to wonder if a relief ship was ever going to come. It didn't. Back in England, Ribault had managed to get himself arrested on a religious charge. Ribault was Huguenot, and even though England was then under the rule of Elizabeth I, who was also Protestant, that was apparently illegal. They didn't keep him locked up forever, but that little bit of folderol cost him precious time. Ribault never did get back to the Port Royal area. Instead, he went back to Florida to set up a colony there.

Meanwhile, back in Port Royal, after only one year, the twenty-eight Frenchmen there were so desperate that one of them had the idea that they should build a ship and sail back to Europe. What a disaster that was. The

boat was small, and the voyage was to be long. They actually did get a boat built, but on the open sea, things went so badly that they were reduced to cannibalism. All of them would have died had not a passing English ship spotted and rescued the poor, starving wretches.

As the French were struggling at Port Royal, King Philip directed that a Spanish fort be built farther south from Port Royal on a good river port in La Florida. What had really alarmed the Spanish was that under Ribault the French had made another effort at securing a permanent colony in the area near present-day Jacksonville, Florida, where in 1564, they set up a fort they called Fort Caroline. This turned out to be another mistake on the part of the French. Within a year, the sailors there mutinied, and using their boats, they turned to looting and pillaging on the high seas in an effort to get the supplies and goods they were not getting from France. On these pirating forays, they unfortunately didn't restrict themselves to simply re-supplying their town with necessities; they also kept any money and treasure that happened to be on the captured ship. This caused a lot of hard feelings all around. These incursion efforts by the French so deep into an area the Spanish considered theirs alarmed the Spanish king, who sent a force to take Fort Caroline.

Under Pedro Menendez de Aviles, the Spanish put into an inlet in August 1565, naming it Saint Augustine in honor of the nearest Saint's Day. At that time, Saint Augustine was only a fort. It was not originally planned as a town or as a colony.

While de Aviles was trying to get a Spanish fort set up, Jean Ribault had come back to Fort Caroline to the north of Saint Augustine with more settlers, hoping to strengthen his efforts there. He also came armed to the teeth with more soldiers and sailors. Ribault, who was not the world's luckiest man, loaded up his ships with his soldiers and sailed down to the new Saint Augustine to have it out with the Spanish once and for all. His luck was running true to form, as he was about two months into what would later be learned was the hurricane season. Poor Ribault and his fighting force sailed right into the jaws of a bad one. While Ribault was trying to keep all his ships from sinking, de Aviles used that bad weather to march north overland and pull a surprise attack on Ribault's Fort Caroline. There were several hundred people at Fort Caroline, but they were mostly women and children and tradesmen types, as Ribault had pulled most of the soldiers out to go with him to Saint Augustine.

Then things got worse for the French.

De Aviles was merciless, and the few Frenchmen who were not killed in the Spanish attack (and that was almost everybody except the women and

the children) ran off into the woods. With the French all dead or hiding out in the woods and the women and children lying around on the ground weeping, de Aviles gave thanks to another saint and renamed the captured fort San Mateo.

De Aviles promptly returned to Saint Augustine and found most of the survivors of Ribault's hurricane-wrecked boats on the inlet of the river. He had his men round up the hapless survivors and took them prisoner. They then walked them down the shoreline, and rather than using their guns, which would have given away their treachery, they pulled out their knives and cut the Frenchmen's throats. Today, the inlet where they were marched and killed is known as Matanzas Bay. In Spanish, "matanzas" means "slaughter." The Spanish executed almost all of the French they had taken prisoner, including Jean Ribault himself. This was no small affair. Approximately 134 of the 150 survivors were killed, as they spared only 16 men. De Aviles then learned that another 111 of Ribault's men were stranded on another beach farther north, and he rounded those up and killed them too. Over 245 of Ribault's men had been killed in his failed efforts to take Saint Augustine. He also lost many men back at Fort Caroline in his disastrous attempt to set up a colony in the area we now call Jacksonville, Florida. Times were very hard in the 1500s.

After dispatching the French at Fort Caroline and the Matanzas Bay area, the Spanish moved up the coast to the very place that the French had occupied on what today we call Parris Island, as Ribault had named it.

The Spanish had learned from the sixteen survivors at Matanzas Bay that things had not gone well up in Port Royal, so they set out in 1566 from their Fort Saint Augustine in Florida and headed up to Port Royal to establish their presence there. They knew the area somewhat, as the Spanish had first been in that area as early as 1521, when Spanish slavers were in the region.

When I say the Spanish went "to the very place" as the French, they were being as precise as one group of soldiers can be when following another group of soldiers. The Spanish landed on Parris Island and built a fort, Fort San Felipe that actually overlapped the same spot on which the French had built Charlesfort, which by that time had been burned and dismantled by the local Indians, so it wasn't in the way.

Indeed, back in 1922 a marine major named George Osterhout, who was very interested in history and archeology, conducted an archeological dig to find the French fort. He found a number of small Spanish artifacts, mistakenly thought they were French and declared that he had found the French Charlesfort. His findings were published to great interest in the

archeological community, and four years later, a large stone marker was erected just outside of what had actually been the Spanish Fort San Felipe. The marker remains to this day, still mistakenly declaring in stone, "Here stood Charlesfort, built in 1562 by Jean Ribault for Admiral Coligny, a refuge for Huguenots and to the glory of France." The Spanish effort is not mentioned on that monument at all.

Once the Spanish were in Port Royal, they found the old French site and moved in. They named the settlement Santa Elena and built themselves a reasonably sturdy fort that they called Fort San Felipe. This was the first effort by the Spanish to colonize in what we now call America that actually lasted more than one year. Up to that point, they had either simply explored, as had Hernando de Soto and Ponce de Leon; conquered, as had Hernando Cortez and Francisco Pizarro in Mexico and Peru; or built forts, as had Pedro Menendez de Aviles at Saint Augustine.

A colony or two had been tried in Santo Domingo as far back as 1492, when Columbus first landed in present-day Haiti. He went ashore on Christmas Day and, true to Spanish tradition, called the settlement there La Navidad. A year later, when Columbus came back, he moved the settlement and settled La Isabella, his second settlement and the first permanent European settlement in the New World. Those efforts were in the Caribbean, however, not on the North American continent. The colonization effort in North America, with the bringing in of women and children and various craftsmen and priests to make a permanent settlement, was mostly new ground for the Spanish.

Things were not smooth for the Spanish either, but it was not nearly as hard as it had been for the French four years earlier. First of all, the Spanish brought their own women, much to the relief of the local natives. Secondly, they were prepared to farm, having brought mostly farmers and their families, and they were prepared to trade with the Indians, having brought a large store of trade goods. Also, the leader of the Spanish effort was Pedro Menendez de Aviles, who had established Fort Saint Augustine and who had killed most of the French there after they tried to take it under the command of Ribault. De Aviles was simply a better organizer and leader than Ribault had been. The labor of building a new fort, houses, a church and so forth was tremendous, but the Spanish had come to stay, and real work was expected. The first contacts between the Spanish and Indians went reasonably well.

Into Santa Elena came not only men with their wives and children but also priests, blacksmiths, bakers, potters, carpenters, farmers, swineherds and even a tailor, a barber and a doctor along with those who possessed the

other skills needed by a new town, as well as the soldiers needed to protect such an operation. Santa Elena even sported a tavern and a boardinghouse as well as a rather sturdy fort. It was, all in all, a proper town and colony.

De Aviles appointed Juan Pardo as the governor of Santa Elena and ordered him to send out exploration expeditions from Santa Elena north and west into the vast rivers and forests there. He told Pardo to find the "northern route to the Mexican silver mines" and be on the lookout for gold. He also told Pardo to make nice with the natives, giving him over a ton of iron and steel implements to trade with the Indians. Over the years, the remains of a few of those implements have turned up in archeological digs in as far-flung places as upland South Carolina, North Carolina, Tennessee and Georgia.

We know a great deal about those Juan Pardo expeditions because Pardo had the good fortune to have Juan de la Bandera as his scribe. De la Bandera was meticulous in writing down everything in his log, including just how many leagues they traveled on any given day, all the important Indians they encountered, exactly how many iron implements were passed out and who, by name, received them and various other facts.

At first, there was a lot of social intercourse between the Spanish and the Indians, including joint feasts, much sharing of Christianity by the priests and the passing out of iron implements, cloth and pottery. But as fate and the behavior of men would have it, life in Santa Elena did not remain harmonious. Twelve years after the settlement at Santa Elena, in 1576, the Indians burned Fort San Felipe. The perpetual problem in Santa Elena was that the land was so poor that food was always in short supply, with the Spanish always harassing the Indians for more. The Spanish were also shooting up the game in the area, thereby reducing the natural resources the Indians needed to survive. This burning of the fort was a great blow to the Spanish, and it forcefully brought to their attention the fact that the natives were not happy.

The Spanish rebuilt the fort and named it for a different saint to see if their luck would be better, calling it Fort San Marcos. In a way their luck was better because that fort withstood an assault four years later in 1580, when about one thousand Indians tried to take it. But as we can see, the natives were still not as happy as they could have been.

The Spanish were in Santa Elena for a generation. Indeed, it was Santa Elena that the Spanish referred to as their "capital" of La Florida. But after twenty-one years, they gave up the idea of having a colony there and withdrew to Saint Augustine. The Spanish decided that they needed the

men, women and more soldiers at Fort Saint Augustine because it had been attacked and burned by Englishman Sir Francis Drake. The Spanish, facing this new English threat deep in La Florida, figured to consolidate their efforts. So the people in Santa Elena moved down to either Saint Augustine or on to Cuba, abandoning Santa Elena.

In the twenty-one years since Santa Elena had been set up as a colony, the fort of Saint Augustine in Florida had seen changes. By then, most of the Indians who were native to that area had either long since died out due to disease or had fled, so that area presented fewer problems than the Santa Elena area. Saint Augustine, re-supplied with colonists moving down from Santa Elena, became the new capital of La Florida.

In truth, the area of La Florida, which stretched from Cape Fear south to the Florida Keys and then west to what is today's Alabama, was simply too vast an area for the Spanish to supply and administer. Additionally, the riches they expected to be coming out of North America simply did not equal that coming out of Central and South America, so it was a better bet for the Spanish king to spend his money there. The constant pushing and shoving among the Spanish, the French and the English for colonies was too costly in both lives and treasure to justify trying to maintain control over such a large area. After a generation in Santa Elena, the Spanish started to consolidate their south Florida holdings and concentrated on working the Gulf Coast area since it was closer to Spanish Cuba. But both the English and the French wisely left Florida and the Gulf to the Spanish.

BARBEQUE IS BORN

The Spanish colony at Santa Elena may not have been an enduring monetary success for the Spanish, but during the twenty-one years the Spanish were in Santa Elena, a wonderful thing happened: barbeque was born!

The Cusabo Indians, the Indians of the south Atlantic shore between what is now Charleston, South Carolina, and Savannah, Georgia, were adept at cooking their meats on a construction of green sticks that kept the meat far enough from the low flames to cook slowly. Actually, that method of cooking was not foreign to most of the coastal tribes. We have drawings of such an apparatus left to us by the Frenchman Jacques le Moyne, one of the artists who accompanied Jean Ribault in his explorations of the Atlantic coast.

Those wonderful drawings that le Moyne made were then turned into engraved copper plates by the Dutchman Theodor de Bry and first published to instant success way back in 1591, when there was much wonder in Europe about those exotic new lands far across the sea. Those de Bry engravings have been in history books for over four hundred years.

The Cusabo were not just one tribe, and neither they nor anyone else referred to them as the "Cusabo." That is the name we have settled on today to try to simplify the various tribes that lived near one another on the coast. In fact, back in 1568, Father Juan Rogel, one of the priests in Santa Elena, wrote that there were thirty different chiefs speaking twenty-four different dialects who ruled over only about two thousand people. Today, we group a number of different Indian tribes under the name Cusabo: Coosa, Cumbahee, Coosoe, Kussoe, Edisto, Escamacu, Etiwan, Tuscamacu, Stono, Wando, Wappoo, Seewee and heaven knows how many more. Not only did the Indians themselves speak different dialects from each other, but the English, French and Spanish who dealt with them over the years all called each of them by different names.

Whatever their name, the more the poor Indians were in contact with the white man, the worse it was for them. No one knew the true source of disease back in the 1500s, even though they did have an idea of contagion. The unfortunate thing is that year by year, dozens and sometimes even hundreds of Indians succumbed to diseases that were imported from Europe and for which they had never built up any immunities. It was a bit of a two-way street, with syphilis being one of the Indian ailments that the Spanish contracted and carried back to Europe, but many more Indians died of European disease than did Europeans who died of Indian diseases.

Despite the real danger that Europeans posed to the natives, the two groups got together frequently to conduct business, as well as for social reasons. The governor of Santa Elena, Juan Pardo, had specifically been ordered to be nice to the Indians, and he was passing out fine iron and steel gifts left and right. These were much prized by the Indians and the Indians were, if not directly aggravated, on good terms with the new Spanish in this wonderful new town that had sprung up by the Broad River.

Santa Elena had a bakery, where bread was baked for the inhabitants, as well as a pottery kiln, where wonderful dishes, bowls, pitchers, jugs and other marvelous things were made. These made great trade items for the Indians as well as useful everyday items for the settler families.

Santa Elena also had a church with several priests in attendance, and the priests, along with the scribes, were always the most educated people

in the village. They were charged not only with the spiritual health of the colony and spreading the word to the heathens but also with training young boys, both European and Indian, in languages so that the two cultures could communicate. Promising Indians were selected to receive an education and were treated lavishly by the standards of the day. Many of these young Indians were sent back to Europe so that they could see the wonders there. They were given very nice clothes, shoes, hats and even spending money. They were treated to trips to the great cathedrals and other architectural wonders. Even the royals received them. The idea was that such a grand tour would convince them that the Europeans were so superior to their people that they would forever be loyal to their new friends. For the most part, this plan worked, and Indian translators did stay loyal to the Spanish (or French or English), who had lavished so much time, money and effort on them.

From the Indians' point of view, life around Santa Elena wasn't nearly as bad as it had been with the French just a few years back. The French had almost managed to starve to death, which caused neighborhood strife, and they didn't benefit the Indians nearly as much as did the Spanish, who were not only passing out iron and steel implements to the men but also colored beads and cloth to the women. Cloth, by the way, was much prized since the Native Americans did not have the loom. They were also sharing that wonderful new animal they brought with them: the pig.

For years, the natives and the Spanish shared their culture and their foods, including the pig. With the Indians' knowledge of barbequing and the Spaniards' knowledge of raising the food source, barbeque became the way the Indians and the Spanish, at least at first, cemented their friendship and cultural exchange.

The Indians had never seen a pig before. In fact, it is a common misunderstanding even today that there were wild pigs or, as most people term them, "wild boars," in the American forest. Wild boars are native to Europe, where hunting them is quite a sport among the upper class. The wild boar can be a savage beast when cornered, and he comes out fighting, using his long, sharp tusks as weapons, so there was always the excitement of the chase. It is from the wild boars of Europe that the pig was domesticated many centuries before they were brought to the Americas.

After the War for Southern Independence, the rich upper-crust families of the northeast were sending their daughters over the Atlantic to marry poor but titled Europeans, and they were aping everything aristocratic. (Winston Churchill's mother was an American from the nouveau riche Jerome family back in New York. Her father had moved her and her

two sisters to England, instructing them to marry titled men. All three did marry titled but relatively poor Englishmen.) During this northern fascination with European aristocracy, George Vanderbilt decided that it would be great sport if he and his wealthy friends could hunt wild boar just like the real aristocrats in Europe.

George Vanderbilt had built the most magnificent house in America in Asheville, North Carolina. Finally completed in 1895, he named it Biltmore House. There, for several months of the year, he settled into the life of a true aristocrat as he imagined it to be. George was known as the spendthrift Vanderbilt, and after the expense of building Biltmore House, he became the poorest of the Vanderbilt clan. But he wasn't so poor that he couldn't have a few dozen wild boars imported from Russia and put on his estate. Out of the original 100,000-plus acres of the vast Biltmore estate, he had a 5,000-acre area enclosed with wire fence and put the newly imported wild boars in that enclosure. He then told all of his friends that in twelve months (to give the boars a sporting chance to adapt to their new environment), they were to take his private train down to Asheville, where they would have a fine old time hunting like real gentlemen did back in the old country.

A year later the boars had long since dug out under the fence and George and friends were left to marvel at the abilities of boars—and the boars were left to spread out over the South. All this was three centuries after the Spanish had brought domesticated pigs to the American continent.

Occasionally, one will read somewhere that Hernando de Soto had pigs (he did) and that some of them escaped their swine herder (some probably did), which led to the beginning of the wild boars in America. That simply is not so. The wild boar is a different breed of pig from the domestic pig, although the two can interbreed since they are both sub-species of the genus *Sus* of the family *Suidae*. In other words, they are similar, but not the same. There is little chance that any pigs from the de Soto expeditions in 1540 survived in the forest for long even if some did escape. Natural predators such as wolves and eastern cougars would have made quick work of them, plus the occasionally pleasantly surprised Indian would have gotten any others of the precious few that managed to slip off from the swine herder.

A while back, there was a short piece on wild pigs done by Fox News in which the reporter attributed the wild boars in the South to pigs escaping from the Spanish in the early 1500s. Those pigs are a world apart from the wild boars that were imported for hunting, but the writers at Fox News

This le Moyne drawing clearly shows the Native American custom of making pots with coils of clay rather than on a potter's wheel, which they did not possess. *Courtesy of the John Carter Brown Library at Brown University.*

don't know that. In point of fact, there are a growing number of pigs that people are calling "wild pigs" or "wild boars" running around that are really feral pigs, offspring of wild boars and domesticated pigs. These feral pigs are causing a great deal of harm on some coastal lands, where they are destroying a good many of the sea turtle nests that the poor turtles build there. These wild pigs are scattered throughout various states now, with an estimated population of over 4 million nationwide.

A look at a worldwide map of the boar range will show that they are far, far more numerous in their old habitat, the Old World, than they are in the southern United States where they were introduced as sporting game. The Spanish, it should be noted, introduced the domesticated pig into every place they went—North, Central and South America—but only in the areas near where the wild boars were introduced for sport, the South, are they living today in any real numbers.

So, the domesticated pig (not the wild boar) was a wonder to the Cusabo, who were about to get a taste of the best meat on the planet. We get our confirmation of Indian barbeque not from Juan de la Bandera of the Spanish expedition but from the drawings of Jacques de la Moyne, who was with Jean Ribault. There are some reproductions of these wonderful le Moyne drawings in this book, and just as soon as you see them, you will recognize the artistic style and even some of the images because so many of them have been reproduced in various history books and on television. If we want to see what the Indian culture on the American East Coast looked like in the 1500s, then all we really have are the drawings of le Moyne and John White. And thank goodness for le Moyne—not just because he was there and did so many nice drawings, but because he had such a keen eye.

In the above drawing, notice the large pot that is sitting directly on the fire. Also notice the rings running around the pot? This is an important

detail that was carefully recorded by le Moyne. The Indians did not have the wheel, which means that they did not have a potter's wheel either. This has generally been overlooked in our modern day, especially with all the southwestern Indian pottery that was produced there from the 1920s onward. All of those pots, however, were thrown on a modern-day potter's wheel, and today, they look so authentic to us that we forget that old Indian pottery looked nothing like these modern-day replications made for the tourist trade.

Most people don't know it, but the oldest Indian pottery in North America is found up the Savannah River, which separates South Carolina and Georgia. This pottery was found on Stallings Island, located near present-day North Augusta, South Carolina. Today, you can find, on both sides of the Savannah River, pottery that dates back 4,500 years.

The only authentic Indian pottery that is still being made in any amount in America today is Catawba Indian pottery, made by descendents of the Catawba people, who still have a small reservation in York County, South Carolina. The marvelous thing is that in addition to making pots and other clay items that we can purchase, they still continue to use the reservation's meeting house as a facility in which they teach that ancient art to younger members of the tribe.

The Catawba still make pottery the ancient way; that is, they roll out their refined river clay into long, thin coils and then build the pot up from the bottom, layer by layer, using those clay coils. You may remember back in kindergarten or the first grade when you were making things out of clay that the easiest thing you could make was a snake, or in other words, a long, thin piece of clay that you rolled out with your hand. Well, that is basic technique that the Catawba use to make pottery, except, of course, the way they do it is not as easy as your childhood playtime experiments.

When the Catawba make pots, they roll out many lengths of clay coils and then stack them one on top of the other in a circle, pinching and pressing the clay where they come together. As the clay dries, they then smooth the outside and the inside of the pot with a small, smooth stone to give it a slick and smooth finish. The clay is then fired in open dirt pits surrounded by burning wood. These Catawba pots are much cherished today by collectors not only for their artistic beauty but also for their handmade authenticity. Nevertheless, not all Indian pottery was made in such an artistic fashion as the Catawba do today. There are examples of shards that clearly show the residuals of the concentric clay coils that were used in the making of the pot.

Here we see le Moyne's depiction of Indians cooking on a rack made of green limbs so that the meat is high and away from the source of the heat. It was with the introduction of the pig by the Spanish, after this drawing was made, that real barbeque was born.

Those circular images that le Moyne noticed and drew in the aforementioned picture are a great example of his eye for detail and authenticity. Also note that in that picture the pot is directly on the fire. Indians used pots for cooking their food just as we do. In the following plate, we see an entirely different set up.

In the above picture, we see a rig set up for barbequing. The meats are far away from the fire so that they will cook more slowly than they would if they were directly on the fire being roasted. Also notice that there is a lot of smoke. Note in the picture the variety of meats being barbequed. There is probably some artistic license being taken in the variety of meats shown since most of those different meats probably would not have been cooked together all at once. A snake would certainly cook more quickly than a dog, and a dog more quickly than the alligator that the Indian is preparing to put on the rack. So rather than making multiple drawings showing each food that the Indians ate, le Moyne probably showed a variety of meats all at once. But the thing that is true to barbeque in le Moyne's drawing is that the animals are being cooked whole; they are

not sliced up into parts. This tradition is continued today when we cook whole-hog barbeque.

When we smoke hams or bacon or any other meat, the animal is cut into pieces. If we tried to smoke a whole hog, we'd find that the heat source is too low to cook the animal evenly. But since the fire is hotter in barbequing than it is in smoking, the whole animal can be cooked evenly without having to cut it into pieces. In le Moyne's picture, we see a perfect illustration of a 1500s barbequing effort, complete with whole animals being prepared. But note that there is no pig in le Moyne's drawing. That is because le Moyne was with the French expedition of Jean Ribault in La Florida, not in Santa Elena with the Spanish. If le Moyne had made his drawings with the Spanish, he most surely would have shown the newly introduced pig.

A Little Sauce History

Barbequing takes much longer than roasting. Barbequing a whole hog takes anywhere from twelve to twenty hours, depending on the size of the hog, and during this time, a temperature range of about 200 to 235 degrees must be maintained to cook the hog evenly. Being exposed to that kind of heat for such a long period of time, the meat has a tendency to dry out on the outside of the animal while on the inside, the collagen is slowly melting, providing tasty juices. Therefore, as barbeque is being prepared, it is best to keep the outside of the animal bathed in some sort of liquid.

As barbeque is being prepared, a cook could, if no other liquid were available, simply use water to help keep the animal moist. And while water will work, it simply doesn't add any additional flavor, and it doesn't help tenderize the meat. What one needs is a good sauce to help with both flavor and tenderness.

Ever since the advent of store-bought barbeque sauce, which was first widely introduced around 1948, there has been much confusion in America about what constitutes real barbeque sauce. Today, most people talk about their barbeque in terms of the finishing sauce that is used, such as a mustard-based sauce, a tomato-based sauce or a vinegar-and-pepper sauce. In reality, almost all barbeque that is cooked for a long time today will use both a basting sauce, applied while the animal is being cooked, and a finishing sauce, which is added in the last hour or two as the barbeque is almost ready to come off the grill. The two sauces serve two different purposes. A basting

Cayenne, one of several peppers native to the New World, are still extensively used in barbeque sauces today. *Courtesy of the author.*

sauce is used to keep the meat juicy, while a finishing sauce is used to add the flavor profile the pit master wants his finished product to achieve. The mustard- and tomato-based sauces are always finishing sauces because the natural and extra sugars that are added to those sauces will blacken and burn the meat if they are added too early in the cooking process.

Regardless of the thousands of individual finishing sauces that pit masters use today, most of them use a basic vinegar-and-pepper sauce as a basting sauce. This sauce is simply vinegar in one of its many forms—white, apple cider, red wine and so forth—mixed with salt and some type of peppers. The peppers used most often today are black pepper and cayenne peppers, though other peppers—such as jalapeño, tabasco or habanero—can be added for extra heat. This simple vinegar-and-pepper sauce has been found over the years to be the best sauce for keeping meat tender and juicy while it is being barbequed. The salt and pepper adds taste, while the vinegar adds flavor while also tenderizing the meat.

Vinegar is a wonderful thing that comes naturally from wine, and it is much overlooked today as the miracle liquid it is. If you simply place grapes in a bowl and let them sit there, the skins will ripen and break open. The

sweet grape juice that seeps out will attract the natural fungus in the air, and that fungus will multiply and eat the sugars in the grape juice and convert those sugars into alcohol. All you need to do to make wine is simply let grapes sit in a bowl, and nature will do the rest. If you want to speed the process up you can mash the grapes.

Of course, that wine will taste pretty horrible but it does have three things going for it. The first is that it is a legitimate source of calories. The second is that the natural alcohol in it will kill most of the bacteria that gets into the stomach, so it is actually better than drinking water. The third benefit of this crude alcoholic beverage is that after drinking a fair quantity of it, you feel much better about the whole thing, including the awful taste. Wine made today, thank goodness, is wonderful stuff being made in controlled environments. It is a marvelous beverage with great benefits to man, and we don't have to drink that awful beverage that nature makes on its own.

Wine is made, as I mentioned, when fungus contacts grape juice, turning the sugars therein into alcohol. Vinegar is made from wine when a bacterium that also floats around in the air comes into contact with the wine. The word "vinaigre" is a French word that means "sour wine," and that should tell you pretty much all you need to know.

You will note on the le Moyne drawing of Port Royal that he includes some of the local fauna, turkeys and deer, to show that game is available to the prospective settlers. Also note that down in the lower right-hand side of the drawing are three types of native plants. He placed these here to show that there were certain types of essential foodstuffs available in the area. One of those three plants that he drew is a grape vine. It should be noted that the grapes that were indigenous to the North American South were not the same grapes that we make almost all wine from today. Today, almost all wine is made exclusively from grapes in the species of *Vitas viniferous* (grapes used to make chardonnay, pinot noir and merlot, for instance, are in that species), whereas the grapes found at Santa Elena were from the species *Vitas rotundifolia*, which contains the grapes we call muscadine. These muscadine grapes were widespread, and the Europeans were delighted to find them because wine and the vinegar made from wine were absolutely essential to life in those days.

Vinegar also has wonderful properties. It has been used as a medicine since at least ancient Greece, when Hippocrates, the father of medicine, wrote of its uses. But the Babylonians and Egyptians were using it a millennia before that. And while vinegar is a wonderful medicine and cleaning agent (the

British used it to clean ship decks, and your grandmother used it to clean windows), what interests us most are its flavor and preservative properties. Vinegar is a great preservative in itself, as you will note as you move your jars of pickles around in your cupboard. Vinegar also lends taste to foods depending on the type of vinegar it is and its acidic strength. Plus, vinegar is a tenderizer of meats.

Remember earlier when I was speaking of what the Indians got from the Spanish—horses, cows and pigs—and what the Europeans got from the New World, which was that list of vegetables? One of the vegetables on that list was "pepper." The New World is the natural home of real peppers, and by real I mean those belonging to the capsicum family. This family of peppers includes the jalapeno (*Capsicum annuum*), the Tabasco (*Capsicum frutescens*) and the habanero (*Capsicum chinense*), among a whole host of others.

What most Americans and Englishmen call "pepper" is actually a fruit (peppercorn) that comes from a small bush found in Southern India. The *Piper nigrum* bush gives a small fruit that, when dried, turns black. Ground up, it becomes what we call black pepper. Today, the ubiquitous black pepper is second only to salt in terms of use in our day-to-day recipes, but *Piper nigrum* is not even in the same category as capsicum when it comes to heat.

As a happy confluence of events transpired, various Indian tribes had access to vinegar, which they made themselves by simply letting grapes sit in bowls, and peppers, which nature provided. In other words, they had a vinegar-and-pepper sauce to use as a basting sauce on their barbequed meats as they were cooking them.

Sauces have become so varied since the introduction of commercially prepared sauces that it is hard to sort out their origins. However, true vinegar-and-pepper sauces being used as both a basting sauce and a finishing sauce are still the staple in the lowcountry of South Carolina and North Carolina. That sauce has persisted for hundreds of years in those coastal areas simply because it was the first one used and has been passed down generation after generation—plus the fact that as the perfect basting sauce, it can't be improved upon. It is only in the areas of the country that do not have a true history of barbeque that other types of sauces are used in basting and finishing barbeque.

In the last chapter of this book, we will delve more deeply into the history of sauces, as the character of the sauce is what most people think of when they think of barbeque. Also, since successful commercial barbeque sauces date back only to about 1927, we can leave that discussion for that chapter.

Nevertheless, the European pig and the Indian art of true barbequing, where the meat is cooked more slowly than roasting but more quickly than smoking, came together over those early twenty-plus years at the first European colony in North America, Santa Elena, in what is today's Port Royal, South Carolina. And the whole world has benefited from those humble and primitive beginnings.

BARBEQUE IN THE EARLY DAYS IN SOUTH CAROLINA

South Carolina may have been the site of the first real European colony, Santa Elena, but as English colonies go, South Carolina was a bit of a latecomer. There were a few white traders, mostly Scottish, crisscrossing the South Carolina backcountry seeking hides from the Indians, but the first English colony wasn't established on South Carolina shores until 1670 on a peninsula in the lowcountry. As we all know, that peninsula was located at the confluence of the Ashley and Cooper Rivers, and the town was named for King Charles II.

The first permanent English colony in the New World was Jamestowne, Virginia, and the second one was Plymouth, Massachusetts, named after the port in England from which the colonists sailed. Jamestowne was settled in 1607, and Plymouth was settled in November 1620.

New York was first settled by the Dutch in 1609, just two years after Jamestowne, and the Dutch called it New Amsterdam, after the city of origin of most of the settlers. Later, in 1664, the English who were living there outnumbered the Dutch and renamed it New York. So, New York beat out South Carolina by many years as a colony.

Pennsylvania also came into existence before South Carolina. The first Europeans who settled there were the Dutch, who set up some trading posts and forts between 1624 and 1626 along the Delaware River. The English (who came slightly later) named the area after Thomas West, the Jamestowne governor (1610–18) who happened to be the third Baron De La Warr, so you can see why it is called Delaware.

Even the Swedes got into the act in the upper bay where Pennsylvania, Delaware and New Jersey come together. By the way, it was the Swedes who introduced the log cabin into America, providing much better housing in the colder climates. Before the introduction of log cabins, the English and the Spanish used a form called waddle and daub, a lattice of sticks woven around poles and then filled (dabbed) with wet clay, which was left to dry. The roofs were thatched.

The Swedes got off to a good start in what is today's Wilmington, Delaware. They had enough sense to buy the land they wanted from the local Indians rather than simply take it at gunpoint, and they prospered as traders. Today, the oldest surviving church in America, the Old Swedes Church, is still standing in Wilmington, Delaware.

As I say, it seems as if everybody was getting into the colony business before South Carolina, but when Charleston became a town, there was no looking back. Most South Carolinians know that the first museum in America was established in Charleston, as was the first theater house, which hosted the first opera in America. Most South Carolinians also know that the first golf course was constructed in South Carolina and that the first public library was opened for those who would rather read a good book on Sunday afternoon than play a round of golf. The first railroad in America was also located in Charleston and when completed ran from Charleston to Hamburg (across the Savannah River from Augusta).

South Carolina may have been late in the colony race, but it made up for lost time with the quality of the people that came to Charleston and the accomplishments of those people. In the 1830s and '40s, Charleston was still the largest city in America, and South Carolina was the richest state in the nation up until 1860. And this wealth had its effect on barbeque.

Robert Moss, a South Carolinian who wrote *Barbecue: The History of an American Institution* (U. Alabama Press, 2010), took on the rise of barbeque in the nation as a whole. In that excellent book, he writes that barbeque really got its best foothold in the culture and everyday life of the English colonists in Virginia, not South Carolina. There are several reasons for this, some of which he mentions, and one that I'd like to stress.

First of all, Jamestowne was settled in 1607, and by 1670, when South Carolina was settled, Virginia was a growing and thriving place. However, things had not been easy in Virginia. The Indian massacre of the settlers in 1622 was a horrible setback, with nearly one third of the settlers being killed. But those hard times had been overcome, and Virginia was up and running with lots of buildings constructed out of locally made bricks while Charleston was still a small settlement of waddle-and-daub houses.

Also, Virginia had an interesting mix of settlers. About one quarter of the settlers who came into Virginia were armigerous, that is, they were noblemen who had a legitimate "coat of arms," as we tend to call it today. Arms were issued only to noble families.

In England, it was the eldest son who inherited all of the family's estate. The second son might inherit if the eldest son died, but the third or fourth son was usually left to his own devices, including going into the military or the clergy or immigrating to new lands to try his luck. This quarter of the population being noblemen had an interesting effect on the first Virginia colony. For one thing, various governors of the colony complained of "gentlemen" who wouldn't soil their hands with a good day's work. Some historians even suggest that all those gentlemen are the reason why Virginia got off to such a rough start.

Another result of having such a large upper class was the effect it had on manners and speech. When a community is all the same, or mostly the same in class, as was Massachusetts (which was, almost to the man, lower middle class), there is no one to look up to and try to imitate, and no one to set the tone for behavior. In Virginia, there were enough gentlemen and ladies of the upper class to set the tone for behavior and even speech patterns, which is why to this day, the soft tones of the upper class in the South sound much like the soft speech of the upper class in England (while the harsh tones of the upper class in New England make them sound like a bunch of London cabbies).

That is not to say that everyone in Virginia belonged to the upper class— far from it. Nearly three quarters of the settlers in Virginia were from the lower middle class or lower class and illiterate. In New England, most of the lower middle-class immigrants in that colony were literate, at least the men anyway, as opposed to the overwhelming illiteracy that was found in Virginia. But New England lacked a real aristocracy to set the standards. There were a precious few aristocrats in New England, but they busied themselves with religion and law and held themselves a bit aloof from the general population, whereas the aristocrats in Virginia were working side by side in the community trying to make a living.

South Carolina followed the Virginia pattern much more closely than that of New England. People came to South Carolina looking to make a good living, not looking for a church to go to. They were already going to church, the Anglican Church, and they didn't see any need to change. They also didn't much care where their neighbors went to church, which is why the Huguenots were welcomed into Charleston (Huguenots were Calvinists, sort of like Presbyterians, not Anglicans) and why the second Jewish

synagogue in the colonies was established in Charleston in 1750. The first Jewish synagogue was established in Rhode Island, which had been formed when Roger Williams was run out of Massachusetts for wanting to practice religion slightly differently. Since the people in Rhode Island were looking for a little latitude in religion, they also grudgingly allowed some Jews to set up a synagogue there.

Charleston can boast not only the second Jewish synagogue but also the first Reformed synagogue in America, as that branch of Judaism was actually founded there. Charleston was supporting two big congregations of Jews when many cities in the United States had none. In fact, the Jewish community in Charleston, which numbered over two thousand, was the largest in all of the colonies.

When the English defeated the French again in 1716, the French Catholics who lived in Nova Scotia had to flee as the English took over their lands. When a boatload of these poor, bedraggled refugees (Acadians, as they called themselves) arrived in Charleston, the city council made them sit on the boat in the harbor for a month while they tried to decide what to do with them. The problem wasn't so much their religion as it was the cost of feeding and housing them. The council eventually hit on the idea of parceling them out, one by one, into people's houses so that they could be absorbed into the colony at the lowest cost per household. It was sort of like a new tax assessment, with each family having to take on the additional cost of one poor Frenchman.

Most of the French Catholics from Nova Scotia bypassed Charleston and went on to Louisiana, naming their settlement Acadia, and became the Cajuns of today. The ones who settled in Charleston blended into the populace rather well (unlike Louisiana), with many becoming prominent and notable. Indeed, the *Robert's Rules of Order* that is so famous was the work of Henry Martyn Robert, a descendant of one of those Nova Scotian immigrant families. When the Roberts first came to Charleston, they pronounced their name "Ro-ber," leaving the "t" silent. They finally gave up that French pronunciation and started pronouncing the "t," making it "Robert." Also noteworthy is the fact that Henry Martyn Robert was still spelling his middle name the French way, and that should remind you that many of the Martins as well as the Roberts found in South Carolina today are also descendants of those Nova Scotian Catholics.

When Haiti exploded in yet another slave rebellion in 1804 (they had been going on since 1751), the blacks there found themselves with a new black "Emperor," Jean-Jacques Dessallines, who ordered the populace to kill

all of the remaining white people, women and children included, that were left in Haiti. After that, only a few hundred of the estimated four thousand to five thousand French Roman Catholics who were still alive in Haiti in 1804–05 managed to escape, and many of those came to Charleston, since Charleston had, by that time, a rather large congregation of Catholics. An old friend of mine named Refo is a descendant of one of those families that escaped Haiti, as is the prominent Lachicotte family that is associated with the Pawleys Island community in Georgetown County. Religion wasn't really a problem in Charleston. Come one, come all. The problem there was making enough money to act like the upper-class Englishmen they all aspired to be.

Charleston, like Virginia, also got its share of noblemen who sported their own coat of arms. These people set the tone for Charleston just as they had in Virginia. But Charleston noble families came from several different areas of England, including Northern Ireland (the Scots Irish), so that set an even more cosmopolitan atmosphere on the streets of Charleston. These aristocrats not only set the tone for behavior and speech in Charleston, but they also got extremely rich (almost immediately) planting and harvesting rice. The Ashley and Cooper Rivers are tidal rivers that flow through flat land. Once the gargantuan task of clearing the forest was accomplished, that flat land could be made into vast rice fields. It took a very large number of slaves to clear the forests and swamps and build the dikes and canals that were necessary to plant and harvest the rice, and their descendants are in the South Carolina lowcountry to this day, as are the descendants of the families that bought them off of the Dutch, English and Yankee slave ships.

These rice fields made the families who owned them the richest families in America. The wealthy planters built large plantation houses along the rivers, but they also built town houses in the nearest towns. Both these plantation houses and the town houses usually had large rooms that were used for entertaining guests. Some even had ballrooms, in which they would host balls several times a year. You must remember that social contact in the 1700s was simply not as it is today. There were no malls or public schools to go to, nor was there an abundance of churches. If a family wanted their sons and daughters to meet some other nice young people, then going to parties and balls was the way they did it. And, of course, there were the much less formal but more fun outdoor barbeques. It was set in a later time of course, but there's even a scene in the movie *Gone with the Wind* in which Scarlet, in her fancy dress, and her various suitors attend a barbeque at Twelve Oaks Plantation.

The records we have today, that is, the written records that show up in newspapers, diaries and such, are generally of the upper-class South Carolinians having their barbeques. Most of their get-togethers were of the more formal type, given their background. Then as now, the South Carolina lowcountry also sported a good number of hunt clubs, where men hunted and had meals prepared from the game they took. It can be assumed that as well as being roasted, the tough venison was, from time to time, barbequed, and it might have been barbequed more often than roasted. Unfortunately, the drinking was rather heavy at these affairs, and if the hunt clubs had a recording secretary to keep up with the membership records, it could be expected that they didn't record exactly what was eaten and how it was cooked. There is even a mention of a "barbeque house" at a hunt club in the Beaufort area. It appears that the gentlemen met there for elaborate meals with lots of drinking and heaven knows what other frivolity, but it was in existence for a couple of generations before a hurricane blew it away. And certainly there had to have been many families that cooked a single pig, or some pigs, for a family reunion or gathering, but if so, they were not reported in the newspapers of the time, so unless they are mentioned in a personal diary, we simply have no way of knowing for certain.

Indeed, my most memorable exposure to barbeque took place back in 1947, when I was only six years old. I was staying at my grandmother's farm on some occasion, and my two uncles dug a pit that was about six feet long and two feet deep in the area between the house and the barn. After digging the pit, they put some hickory wood in it and burned it down into coals. They then laid several stout iron bars across the pit, which they kept in the barn for just such an occasion. By the time the coals were ready a pig had been killed and cleaned right in front of my astonished eyes. All night long, one of my uncles would baste the pig with a vinegar-and-pepper sauce that he had made up and put in a large bucket. For a basting mop, he used a long wooden handle from some old, worn-out broom that had some rags tied to the end. I got to stay up very late to watch, and I felt as if I were being inducted into some ancient rite of manhood. You can imagine what a remarkable effect all this activity had on a young boy. That was then coupled with the fun that followed the next day as family and friends came to celebrate whatever it was that was being celebrated. That whole event made for a picture that is burned indelibly into my memory. That practiced event was so common in the early 1900s that it had to have been repeated tens of thousands of times over the years all across the South from even the earliest times, as the at-the-ready iron bars attested.

An in-ground barbeque pit. *Courtesy of the author.*

And while a family barbeque may have been much more common in 1947 than it was in 1847 or 1747, it wouldn't have been any more difficult back then. There had to be many thousands of family barbeques in the early days, but as I say, any records of them are virtually non-existent.

We do know that the early planters had barbeques and roasts, as well as larger formal affairs, but again, any record of them is slight. Nevertheless, they did take place, and probably more often than we imagine.

On the other hand, it was commonplace for large social events to feature barbeque as well as barbequed lamb and turkey. So commonplace was barbeque in the state that a mention in a Charleston newspaper in 1792 even uses barbeque to make a satirical point. On May 28, 1792, in a piece on dueling in *South Carolina State Gazette*, Hugh Brackenridge, Esq., wrote:

> Since I am no cannibal to feed on the flesh of men, why then shoot down a human creature, of which I could make no use? You might make a good barbecue, it is true, being of the nature of a raccoon or an opossum; but people are not in the habit of barbecuing anything human now.

The point is that even though barbeques are not often mentioned in the slim newspapers of the 1700s, which were full of more serious news, Brackenridge could use the word "barbeque" in satire and everyone knew what was meant.

There is a reason why barbeque is never the answer to the question of what's for dinner, and that reason is simple: real barbeque takes hours and hours to cook, oftentimes twelve to twenty hours, so no one fixes it for supper. When barbeque is served, it is always special. It has taken a talented cook many hours and lots of hard work to prepare. Given that it is always special, we can then expect that it was served at special occasions rather than everyday meals, which indeed it was. The *Carolina Gazette*, under the headline "Abbeville Court-House, July 4th, 1801," tells the story of how Captain Bowie's troop and Captain Hamilton's company of artillery paraded through the town and ended up in front of the courthouse at about noon: "The company then repaired to Hamilton's Hotel and partook of a well-provided barbecue, prepared for the occasion—Major Andrew Hamilton presiding, and Richard A. Rapley, Esq. acting as vice-president."

In almost every newspaper in the 1800s, there are numerous mentions of barbeques at Fourth of July celebrations as well as political rallies and outdoor speeches of all types. When I was researching old newspapers in the library, one computer program pulled up over three thousand mentions of "barbeque" in the newspapers in South Carolina from 1792 to 1923. Public barbeques were mentioned several times in almost every year in the 1800s up until 1863, when they became non-existent due to the hardships imposed by the war.

In reading over hundreds of these newspaper mentions, it is obvious that barbeques were large affairs that ranged anywhere from a couple of dozen people to one affair in Louisville, Kentucky, in which Henry Clay drew a crowd that was estimated at twenty-five thousand people. The June, 22, 1840 issue of the *Southern Patriot* noted, "The barbecue given to Mr. Clay was a brilliant affair. Nearly 25,000 persons were present, 3,000 of whom were ladies. Mr. Clay's speech was one of the most brilliant and powerful he ever uttered."

The most common events to feature barbeque during the early 1800s were political stump speeches and Fourth of July celebrations. During these occasions, hundreds and even thousands of people came together and were treated to barbeque and, usually, much drink. However, there were some local celebrations that did without alcohol. One interesting write-up of such

a Fourth of July event can be found in the *Greenville Mountaineer* in 1830. Not only did it give the full text of all thirteen of the toasts that were made by the speakers at this festive occasion, but the writer also noted "that not one drop of spirituous liquor was drunk at the table." One can only wonder what was being consumed by the speakers and toast makers as the toasts were being made. Maybe they were toasting with apple juice. The paper noted:

> *On Saturday, 3rd of July, a very large assembly of the citizens of Spartanburgh District met at Timmons' old field, and at 12 o'clock, the Declaration of Independence was read, after which an eloquent oration was delivered by H.J. Dean, Esq., which met with universal applause by the hearers. The following regular toasts were then read, which were responded by the roar of cannon and shout of the citizens.*

From my survey of the hundreds of reports of Fourth of July celebrations, it seems as though the abstemious Spartanburg event was the exception and certainly not the rule.

The Fourth of July was an ever-ready excuse for a good old-fashioned patriotic get-together for every local community. As I say, hundreds of them were reported in various local newspapers, with much attention paid by the newspaper writers as to who spoke, who gave toasts, how many people attended and what was eaten and drunk.

The Fourth of July was not the only excuse for a political barbeque, however. The unfair tariffs of 1824 and 1830, which the United States Congress passed favoring northern shipping and commerce over southern commerce, led to the nullification controversy that roiled the nation in the late 1820s and early 1830s.

In 1832, the South Carolina legislature passed the Ordinance of Nullification, which almost led to a sectional war between the United States government and the state of South Carolina. John C. Calhoun, the vice president of the United States, was on one side (the Southern side), while President Andrew Jackson was on the other. These are, to say the least, two heavyweights in any controversy. South Carolina threatened to secede, and Jackson threatened to send federal troops. As you can imagine, this controversy caused many political speeches to be made both pro and con on the subject. And while the local newspapers took one side or the other in hopes of appealing to their readers, one gets the feeling that the speeches given by the politicians, along with the barbeque and drink, had much more of an effect on the population than the editorials.

In the September 19, 1830 issue of the *City Gazette and Commercial Daily Advertiser*, we find the following hyperbolic editorial in which the editor takes aim at politicians who use drink and barbeque to, as he sees it, lead the population astray:

The State itself is threatened with danger when an influential profession, whose trade is talking, becomes discontented and restless—when they find business fails in the Court House, they will seek it in the Court Yard through the Press and at the Barbecues, where Brandy gives fervor in the power of eloquence. And by the aid of a ready pen, a glib tongue and a strong Brandy, they can almost make a credulous farmer believe that his best course to pursue in dull times is to convert his pruning hook to a spear, his ploughshare to a sword and exchange the quietude of the domestic alter and the innocent prattle of his children for the sufferings of the camp and the impious imprecations of a callous soldiery.

Because barbeque is always special, taking time and talent to prepare, it was traditionally used to attract locals to special events such as holiday celebrations and political rallies. Barbeques were such a part of the fabric of the community that the populace had come to expect them. In fact, it was such a draw for the community that northern politicians started using it to draw crowds in spite of the fact that barbeque was strictly a Southern institution. In the August 28, 1856 issue of the *Charleston Courier*, the writer, after doing a long negative piece on the first presidential candidate for the Republican party, John C. Fremont ("Free Soil, Free Men, Fremont" was his political slogan), wrote toward the end of his essay:

We give cheerfully a quitclaim—but no warranty—to all right title and interest in and to the John C. Fremont aforesaid, throwing in therewith certain tokens, testimonials, expressions of sympathy and friendship, given and bestowed when Southern hearts were touched by the tales of oppression and persecution; let all go but by the recollection of the past and the hopes of the future, we protest against the efforts made by Northern operators to steal away our Barbecues.

That is "going the whole hog" to a degree beyond our taste and inclination, and moreover, the barbecue is so peculiarly a Southern Institution that like every other good thing stolen from us, it will degenerate at the North.

We see that the attempt is being made in several places at the North to naturalize the barbecue, and we shall watch the issue without expectation however of any other result that signals failure.

As the thousands of notices of barbeques in t
Carolina attest, barbeque was not a solitary affair.
restaurants where a person could go with his fam
together in crowds. That number may have bee
members of a family or a hunt club, the hundred or
congregation or the thousand or so celebrants of a l
in a crowd.

Headlines in the August 15, 1905 issue of Columbia's *The State* newspaper read, "The Volunteers' Barbeque." The sub headline proclaimed, "Ninety-second Anniversary of the Richland Volunteers will be Held Today." The next day, the paper had a long write-up of the affair that covered the shooting contests and who spoke at the event. If the Richland Volunteers were holding their ninety-second get-together in 1905, that means it had to have gotten started back in 1813 during the War of 1812. While each and every year since 1813 might not have seen a barbeque, it is very likely that for many generations, the organization held an anniversary barbeque each year.

Although barbeque restaurants were not readily found at the turn of the century, the populace was well acquainted with the food and had been for hundreds of years. It also appears that any outdoor gathering was a good excuse to hold a barbeque, as two write-ups in *The State* illustrated. One write-up was headlined, "Will Give Barbeque—Barbers Reorganize and Plan to Entertain," while the other was headed, "Bar Association Barbecue." *The State* went on to note, "The Bar Association of Richland County had a very pleasant time yesterday at the annual barbecue which was served at Hyatt Park by Mr. Kiah Dent. The dinner was one of the best that Mr. Dent has ever served."

Of interest to us is also the mention of Hezekiah Dent (or Kiah Dent, as he was known to friends and family) in that newspaper's notice. That is not the only time Kiah Dent was mentioned in the newspapers as having supplied the barbeque. That notice of the bar association was found in the July 7, 1905 issue of *The State*. Just two weeks later, a notice in the July 21, 1905 issue has Kiah Dent preparing the barbeque for Camp Hampton, which was also holding its annual barbeque at Hyatt Park. Not only was Hyatt Park proving to be a favorite gathering place, but individuals were also beginning to emerge as being experts at preparing barbeque and earning a good reputation. Kiah Dent has a German name, as do several others who were selling barbeque at that time. Later on in the twentieth century, men of German heritage seemed to predominate in the barbeque business in central South Carolina.

new century progressed, the political barbeques were still much evidence, and the clubs, lodge halls and churches were still holding their dinners to celebrate one event after another. Then an idea arose that seemed to catch on rather quickly, as only an idea that makes a profit can.

There had been other instances of a church holding a barbeque for the public and charging a fee to help raise money, but it took a growing city with a growing public transportation system, the trolley, to allow a reasonably large crowd to gather to make these affairs worth the time and effort as a real moneymaking venture. In the newly developed area to the east of Columbia known as Shandon, real estate promoter Robert Shand had built a large pavilion in a park, and he encouraged groups to use that pavilion for one gathering or another in the hope that as people from Columbia came out to that area, they might decide to move into what was then a new suburb. (Shandon was named for Robert's father, the longtime pastor of Trinity Church, not himself). Robert Shand's Pavilion was located near Devine and Harden Streets in what today is known as Five Points. Today, the Five Points area is virtually the heart of Columbia, but in those days, it was considered the outskirts of the city.

In 1909, after witnessing the popularity of the Fourth of July barbeques, somebody at the Shandon Methodist Church came up with the idea of hosting their own barbeque and charging a fee for the food. So in the July 1, 1909 issue of *The State*, under the headline "Barbecue at Shandon," a newspaper writer put in a blurb that on Monday, July 5 (which was to serve as the holiday since the fourth fell on a Sunday), the Shandon Methodist Church would put on a dinner cooked by the locally famous Kiah Dent, with the funds raised to go to the purchase of a lot on which the congregation planned to build its new church. This dinner must have been a hit, because on September 3, 1909, just two months later, the church people placed a large, two-column ad in the paper announcing a Labor Day barbeque. "Come One, Come All," beckoned the ad, listing a price of seventy-five cents for adults and thirty-five cents for children. There was no mention of Kiah Dent in that ad, so the men of the church probably took on the barbequing themselves to save the catering fee.

In 1910, the Shandon congregation returned with a Fourth of July barbeque. Another ad, not quite as large or as costly as the previous Labor Day ad, announced a Fourth of July barbeque dinner for seventy-five cents. It was again, "Come One, Come All." In two years, with proceeds from several barbeques and booths at the state fair—along with generous contributions from the congregation, I'm sure—the Methodists had built themselves a nice, new church. *The State* reported:

The Methodists of Shandon have, by their pluck, during the past two years, built this substantial and beautiful brick church you see here. The movement for a Methodist Church for this beautiful suburb was begun by Colonel D.P. Duncan, brother of Bishop Duncan. Sunday school then using the old school house for their Sunday school rooms. This little bunch of Methodists always have on July 4th a barbecue for the benefit of the church. They also have a booth at the fair grounds, which has a reputation all over the state for a good place to eat.

This accomplishment did not go unnoticed by other churches and civic groups. In 1914, the Ladies' Aid Society of the Christian Church held a barbeque at Hyatt Park on Thursday, June 19. The society charged one dollar a ticket and announced that Harry Dent (not Kiah Dent) would do the cooking. Kiah Dent had made such a good name for himself in the community that it is reasonable that his son, if indeed Harry was his son, who had helped him and learned at his side, would capitalize on that good name by continuing to both cater and sell to the public from a place of business.

There is another type of short ad that appears in *The State* and other local newspapers that is of interest to us. In the early 1900s, these ads began appearing in the classifieds section of the papers under a separate heading for "Barbeque," just as there were separate sections for Personals, Typewriting Services, Real Estate, Help Wanted or any other area of interest to a large number of readers. There had to be enough people interested in buying barbeque on a regular basis that they wanted to be able to pick up the newspaper and check the want ads to see who was offering barbeque that week. Rather than just waiting for some occasion or for some group to offer it, the populace was beginning to demand barbeque more often. The newspaper owners, seeing this demand, set up a separate heading for barbeque in their classifieds, similar to today's Yellow Pages listings for barbeque restaurants.

Back in 1915, under the want-ad heading "Barbeque," T. Jones Slice announced that he would be selling barbeque at this home in White Rock, South Carolina, and over the years, others would do the same. In that same year, the Episcopalians had taken a page from the Methodists' playbook. There was a big blurb in *The State* on December 2 inviting the public to come to St. John's Congaree, which is way out in south Richland County, to partake of barbeque along with homemade candies and cakes. The church included in its ad the statement that "motor parties from Columbia" would

be especially welcome. By 1915, the automobile craze that Henry Ford started in 1908 with the Model T had obviously come to Columbia.

The following year, in 1916, the good ladies at St. Peter's Catholic Church were not to be outdone, and they announced a big Fourth of July barbeque, with the proceeds "to be added to the church's funds."

The greatly noticed success of the Shandon Methodist Church in that 1911 news story that talked of their new, substantial, brick church had set off a steady stream of church and civic groups holding regular barbeques all through the year to raise money for one good cause after another. Within a few years, every town in South Carolina saw local ladies' auxiliaries and men's civic clubs answering the growing public demand for barbeque. The following notice from *The State* is just one of many that mentioned churches giving barbeques. This one points to the fact that the market for barbeque was such that even bad weather could be overcome in the efforts of churchmen and women to help the collection plate: "Not withstanding the inclemency of the weather, quite a neat sum was realized at the barbecue given yesterday at Thomas Grove for the benefit of the Waverly Methodist Church."

This more frequent serving of barbeque, in turn, helped stimulate such an appetite for barbeque that meat markets stepped up their offerings of this prepared meat along with their usual fare of fresh meats. In 1914, we find an ad in *The State* for Bihari's Delicatessen in Columbia. Bihari's bragged that its barbeque was "very fine and made by an expert in the line." Bihari's Delicatessen was located at Miller's Market at 1601 Main Street (location of the present-day Mast General Store), and Bihari was advertising that his barbeque was not only made by an expert but that he would also deliver it to your home. It can be assumed that several days a week, the businessmen in the area took Bihari up on his often-published offer and carried some barbeque home for supper. So, during the early 1900s, barbeque was gaining a foothold in the diet of South Carolinians on a much more regular basis than it had been in the 1800s, when it took a holiday or a political stump speech to make it available.

By the 1920s, there was a large and growing demand for barbeque that was being met by a good number of vendors on a regular basis. The selling stage was still primarily the meat market, which is the logical place for vendors since the market was in a fixed location and customers were used to coming there to get their meats. And if we take a look at the pages of a local paper in the early 1920s, we see a very interesting thing happening on the barbeque scene—we see a growing competition among vendors for the public's patronage. Smith's Market boasted of its "real barbecue cooked over

a pit by an expert barbecue cook." In 1922, S.E. Perry placed an ad under the title "Bucket Barbecue," by which he meant "barbeque to go." "For the 4th of July," the ad stated, "call at S.E. Perry's and get your money's worth." A Palace Market ad even had a real discussion of barbeque, proclaiming, "Barbeque doesn't mean just cooked meat, but the choicest of pigs and lambs, roasted slowly from 8 to 12 hours, brown and crisp and seasoned as few know how." And in one of its regular ads, Hendrix's Market advertised, "Pork per pound at 75 cents, Mutton per pound at 75 cents and hash at 40 cents per pound." So, in one 1922 issue of *The State*, there were at least four vendors vying for the public's patronage with competing ads. Newspapers all over the state were also carrying ads placed by owners of meat markets that offered barbeque even if there wasn't quite as much competition as there was in the capital city.

No longer could the general public wait for a political speech or a church group to stage a dinner to raise funds; they wanted barbeque available weekly, and the vendors were vying for their business. The fact that some men were establishing a good reputation for being able to cook barbeque was leading up to the inevitable barbeque restaurants that were to follow.

Chapter 4

BARBEQUE COMES INTO ITS OWN

By the 1920s, people had demonstrated that they wanted to eat barbeque on a weekly basis, and there were vendors ready to supply their wants. As we noticed in the newspapers, barbeque was available to all comers at meat markets as well as at special events. Plus, service organizations, churches and charities were getting into the act, providing barbeque for their communities. There were people selling barbecue out of their homes, and it was also available at a few roadside stands. All of these helped meet the demand for barbeque. However, it was the meat markets, which generally carried barbeque at least once a week for their takeout customers that helped pave the way for barbeque to come into its own.

There has been a bit of discussion as to just where the first barbeque restaurant was opened. While doing a bit of genealogical research, Robert Moss, author of *Barbecue: The History of an American Institution*, stumbled across a notice in the *Charlotte Daily Observer* posted way back in 1899 by a Mrs. Katie Nunn, who was running a grocery store in Charlotte, North Carolina. Mrs. Nunn noted, "Call at the barbecue stand for good barbecued meats, beef, pork and mutton. Well-prepared by the only barbecuer in Charlotte."

Unfortunately for Mrs. Nunn, her store was gone a year later, and her operation was a "stand" rather than a sit-down eatery. She probably had a shed behind the store where the meat was cooked and purchases could be made. But as Moss says, it's the earliest notation he has found of someone selling to the public from a single location.

In his book *Holy Smoke: The Big Book of North Carolina Barbecue* (another great book that should grace the shelf of every barbeque aficionado), John Shelton Reed wrote:

> *The North Carolina Museum of History's online "History Highlights" has two entries for 1924: the founding of Duke University and the opening of Bob Melton's Barbecue in Rocky Mount. It's not clear why Duke gets equal billing. North Carolina already had a university, after all, while Melton's, on the banks of the Tar River in Rocky Mount, seems to have been the state's very first sit-down barbecue restaurant.*

As usual, Reed nails it. A sit-down restaurant for barbeque was a momentous event.

As I commented in an earlier chapter, barbecue stands were becoming more frequent in that the people who made a reputation for themselves at courthouse gatherings and by catering local festivities set up small stands in various places around the South, including their homes. Some of those stands eventually evolved into restaurants.

However, there was a sit-down restaurant opened in Columbia before that one in North Carolina. An ad placed by the Palace Market in a June 1921 Columbia newspaper alerted the public that it was not only selling barbeque once a week at their market, which was on Taylor Street in downtown Columbia, but also preparing it to be served at Victory Park, far north of downtown. This was an affair where "ladies and gentlemen" could get a plate, sit at the tables that were provided and eat. It should be noted that a plate of barbeque at Victory Park being served by the Palace Market was $1.00 per plate at the same time that the Palmetto Restaurant in downtown Columbia was advertising a sit-down lunch during the week for only $0.50. Adjusted for 2013 prices, that $1.00 plate comes to $13.15, so the Palace Market was making money, and people were willing to pay over $13.00 in today's money for a plate of barbeque that they could enjoy on a nice veranda at a sit-down venue.

Hyatt Park, which had been the scene of so many civic barbeques before, became Victory Park after World War I. Victory Park was just a short walk, "a stones-throw" as the newspaper put it, beyond the trolley lines that had been newly extended specifically to take townsfolk to that park. Those new lines went from the center of town all the way past where the old Eau Claire City Hall building is now.

According to John Hammond Moore in his book *Columbia and Richland County* (USC Press, 1993), Hyatt Park had been set up in 1897. It was a

BARBECUE

These hot days are good barbecue days. Lamb, pork and hash ready at 11:30 o'clock. We will also cook a cue every Wednesday at Victory Park for ladies and gentlemen. $1 a plate.

PALACE MARKET

1222 Taylor St.

The Palace Market had a sit-down barbeque every Wednesday at Hyatt Park for one dollar per plate, a pricy lunch in those days. *Courtesy of the author.*

welcome addition to Columbia, as there were only a few public parks in the city, and those that existed were small. Hyatt Park was so popular with Columbians that it was the sole reason Eau Claire was initially incorporated into a town.

Hyatt Park was a fancy operation with a big meeting pavilion, described in the newspaper as designed like an East Indian bungalow and listed as "80 feet long and nearly as wide." The paper also noted that there was a twenty-foot-wide veranda around the building that "gave an excellent view of the city."

After the trolley line was extended out to the Eau Claire area, that part of the town quickly developed into a recreation destination for the citizens of Columbia. Just four months after Hyatt Park was opened, the Richland Country Club, which was actually Columbia's first "country club," was set up nearby, and a few years later, in 1904, the Ridgeway Country Club was also opened close by.

All in all, north Columbia sported several recreational and entertaining facilities that saw many civic barbeques. But one operator, Palace Market,

was serving a weekly barbeque there as a sit-down experience for several weeks during the year as early as 1921. And remember, in the 1920s, even North Carolina's Melton's did not serve barbeque every day; it was open only a few days each week. So, a few years into the 1920s, people were ready for sit-down barbeque restaurants in the South.

Of course, I'm using the word "restaurants" loosely. While the Palace Market was serving "ladies and gentlemen" at the East Indian bungalow–style building, most of these new eateries were little more than shacks with cement floors, some wooden tables and chairs and scant decor. But by allowing people to sit down, it was definitely a step in the right direction.

It seemed as if everyone was making money both during and after World War I, from 1914 all the way to the end of 1929. For a decade and a half, the money was rolling in, for farmers as well as the city folk. In the northern cities, this period was known as the "Flapper Age," and speakeasies were springing up to help ease the burden of the Eighteenth Amendment, which had seen Prohibition voted into thirty-six states in the years the men were away fighting the war. People were on the move. They generally had to go out of the house to get a drink, so a speakeasy became a choice destination, as did restaurants. People could, thanks to the automobile, go down the road a bit to get some barbeque rather than having to pick it up downtown at the meat market. A barbeque restaurant didn't have to depend strictly on foot traffic as the downtown meat markets had.

World War I had made many farmers and merchants in the South rich, as millions of yards of cotton cloth were needed for uniforms and other wartime uses. The war also poured money into food crops, especially wheat. After the war, during the 1920s, the expanding American economy and the booming population made for more economic good times. The 1920s were so good that even the soon-to-be-devastated farmers on the American Great Plains were making good money. Their wheat crops were selling anywhere from a low of $0.50 a bushel to a high of $2.00 a bushel, with $1.00 a bushel being commonplace. Adjusted for inflation, $1.00 in 1925 equals about $13.20 in today's economy. Can you imagine what $1.50 and $2.00 a bushel did for wheat farmers? That kind of money can mount up in a hurry. By the 1920s, people had extra money to spend, and they were getting used to the idea of going out to a restaurant to eat.

During this time, everyone in America was better off than they had been only a few years before. So for a decade and a half, before everyone had to start tightening their belts during the Depression and the Dust Bowl, the good times rolled. And barbeque restaurants came into being—not at a roll, but inching

along with the good times. Of course, there had been places to eat ever since people began to travel. In colonial times, every stop had its hostel or tavern, where travelers could get a room and a meal. In the 1800s, every town had at least one boardinghouse or a small hotel that served meals. The businessmen of the 1920s, regardless of the town or city, had a number of downtown cafés and restaurants to serve them for their daily breakfast or lunch.

Then as today, the competition was getting stiffer among restaurants and cafés, and some went the way of today's inexpensive eateries, running ads advertising meals for $0.50. Palmetto Restaurant on Columbia's Main Street had advertised itself as a place that catered to the high-end trade ever since 1908, but in 1920, it switched tactics and started advertising to the cost conscious. You should note, however, that a $.050 meal in 1920 adjusted for inflation is about $5.30 today, but that is still a reasonable price for a sit-down meal.

There was, in general, an expansion of cafés and restaurants in towns and cities all over the country. There were even ads for Chinese restaurants in the want ads before the turn of the century in 1899 in Charleston. The Shanghais Chinese Restaurant was advertising in Columbia by the 1920s. A variety of restaurants were on the rise all over the nation and in South Carolina.

Nevertheless, barbeque restaurants were not as common as other types of restaurants, just as they are not as common as others restaurants are now. Between 1935 and 1955, the Columbia City Directory did not have many restaurants listed, much less barbeque restaurants. However, there is one exception to this: the year 1945. I'm just guessing here, but it was probably the universal joy that World War II was over that caused everyone to become so optimistic in 1945 and take the steps they thought necessary to expand their businesses. The 1945 Columbia City Directory had twenty-two different ads from various restaurants that ranged from the usual quarter-page ads to full-page ads. There were also a large number of listings in the "Female Help Wanted" section for waitresses. In the fall of 1946, there was a long list of jobs for waitresses in Columbia, as thirteen eateries were asking for help: Uneeda Café, Drake's, N&G Grill, Lanier's, Harvey's Café, Ship Ahoy Restaurant, Elite Café, University Grill, Eckerd's Drug Store, Lane Drug Store (for a soda dispenser), Metropolitan Restaurant, Market Restaurant and Frank's, which was located nearby Sumter. Note that Frank felt he had to go outside of his area to get help.

The Columbia City Directory, however, was probably not the best place to advertise a restaurant, so by 1948, the number of ads in the directory had

RESTAURANTS—DRIVE-IN 245

Kittrell's Barbecue Kitchen

BARBECUE
By
Sandwich, Pound or Pig
CHICKEN
SEA FOOD

2308 ROSEWOOD DR. TEL. 3-9296

Even though Kittrell's was offering seafood and other items, the name of the restaurant was Kittrell's Barbecue Kitchen, and that was its main food. *Courtesy of the author.*

RESTAURANTS 153

SHADY HOLLOW BAR-B-Q
WE SERVE REGULAR MEALS FAMILY STYLE
PORK AND CHICKEN BAR-B-Q ON PREMISES OR TO GO

1917 AUGUSTA RD.
WEST COLUMBIA, S. C. TEL. ALpine 3-1024

LEVER'S BARBECUE
ALL KINDS OF DINNERS SERVED ANYWHERE
LEVER'S FAMOUS BARBECUE SAUCE
BARBECUE CATERING, FINE QUALITY

Rear 500 Sunset Blvd. Behind Huckabee Trucking Co. Tel. ALpine 2-6278
West Columbia

dropped by 90 percent, with only two ads being taken out. There was also a postwar inflation going on then, and economic times were a bit tougher. In 1952, there were still only two ads for restaurants in the Columbia City Directory, and neither of those ads was for a barbeque restaurant. Obviously, there were other city directories around the state, but the story was probably about the same. However, none of the restaurant ads from 1945 to 1948 were for barbeque restaurants.

Indeed, in the 1930s and '40s, there were hardly any barbeque restaurants even in the various city directories from around the state. But by 1952, the first city directory ad for a barbeque restaurant in greater Columbia showed up. This ad was for Kittrell's Barbecue Restaurant, which was located at 2308 Rosewood Drive. Kittrell's had opened in March 1947, according to a story in *The State*, so it was an established business before that ad had appeared.

In 1954, an ad showed up in the Columbia City Directory for the Barbecue Inn, which was located at 100 Charleston Highway in West Columbia. However, after that, ads for barbeque houses disappear from the directory until 1960, when both Lever's and the Shady Hollow operation had taken out quarter-page ads in the local city directory.

By the late 1940s, there were ads in the Yellow Pages for barbeque houses, and in 1954 in the Columbia Yellow Pages, there was a display ad for Pampered Pigs Pit Barbecue, which was out on the 4700 block of Devine Street, on the outskirts of town in those days. The interesting thing is that the restaurant was listed in the "Barbecue" section of the Yellow Pages, as the telephone company had long since learned to separate barbeque restaurants and barbeque stands. In the barbeque restaurants section, there were five different sellers of barbeque listed that year, with six different outlets: Kittrell's Bar-B-Q, Lever's Barbecue, Pampered Pigs Pit Barbecue, Shady Hollow Barbecue and Sox's Twin Bar-B-Q Drive Inn, with locations on 724 Harden Street in Columbia and 100 Augusta Highway in West Columbia. Also over in the "Restaurants" section of the Yellow Pages was Piggie Park, which listed locations in both West Columbia and Columbia, on Sumter Highway. Apparently, Maurice Bessinger was already thinking at that early stage of opening a string of barbeque restaurants.

Opposite, top: The Pampered Pig did a good catering business and advertised in the Yellow Pages. *Courtesy of the author.*

Opposite, bottom: Note the two addresses on this early Piggie Park ad. *Courtesy of the author.*

26 Banks—Batteries

CLASSIFIED TELEPHONE DIRECTORY

Banks—(Cont'd)
SOUTH CAROLINA NATL BANK
1401 Main3-3361
Chairman of the Board 1401 Main2-4821
(See Advertisement This Page)
State Board of Bank Control State House4-7078
Victory Savings Bk 1107 Washington.........2-4059

Bar Supplies
BOND EQUIPMENT CO
1220 Lincoln2-0352

Barbecue
Bar-B-Q Inn W Cola.....................2-9364

Merchants and business firms appreciate being told how you found them. Tell them you used the Classified Telephone Directory.

Barbecue—(Cont'd)
KITTRELL'S BAR-B-Q KITCHEN

GENUINE SOUTHERN STYLE
BARBEQUE
PIT COOKED - SEASONED RIGHT
NEIGHBORHOOD DELIVERY

2300 Rosewood Dr...................6-9236

LEVER'S BARBECUE
W Cola2-6278
Pampered Pigs Pit Barbecue 4701 Devine.........4-9524
(See Advertisement This Page)
Shady Hollow Barbecue Place
1917 Augusta W Cola.................3-9173
SOX'S TWIN BAR-B-Q DRIVE INN
724 Harden4-1400
No 2 W Cola.....................3-9179

Barber Shops
Arcade Barber Shop Arcade Bl4-3865
Blue Palace Barber Shop 1003 Washngtn.........6-9891
Brown's Barber Shop 1114 Harden..............4-9291
City Barber Shop 1314 Main..................6-9377
Davis Frank Barber Shop
We Need Your Head In Our Business
2242 Gervais6-9156
Forest Lake Barber Shop Forest Dr...........4-9197
Holt's Barber Shop 2021 Devine.............4-9243
Hotel Wade Hampton Barber Shop 1201 Main...2-3621
Hudson's Barber Shop
Hair Straightened—Massages—Haircuts—For Colored
2354 Gervais3-9387
Imperial Barber Shop 1211 Taylor............4-9474
Jefferson Hotel Barber Shop Jefrsn Htl..........4-8943
Lafayette Barber Shop 1010 Washington.........3-9146
Lilliewood Barber Shop 1121 Washington.........4-9549
Lybrand's Barber Shop 1202 Calhoun...........6-9602
M & W Barber Shop 1707½ Main...............4-9393
Marion Hotel Barber Shop 1611 Sumter.........4-9200
North Columbia Barber Shop 2625 Main.........4-9422
Service Barber Shop 2342½ Gervais............9-9618
Shandon Barber Shop 2819 Devine...........2-6811
Simuel Barber Shop 1202½ Heidt.............6-9742
Smith C E Barber Shop 1127 Washington.........9-9488
State Farmers Mkt Barber Shop State Farmers Mkt..4-9443
TEMPLE'S BARBER SHOP 2368 Taylor..........3-5931
Younginer's Barber Shop 1435 Sumter..........4-9109

CLASSIFIED words are Buy WORDS.

PAMPERED PIGS PIT
BARBECUE
Dial
4-9524
• TAKE OUT ORDERS—CALL AND WE WILL HAVE IT READY
• WE CATER TO BARBECUE PARTIES
BARBECUE
SANDWICHES - PORK RIBS
CHICKEN & HASH BY THE SANDWICH
POUND OR PLATE
STEAKS, CHOPS & SEAFOOD IN SEASON
4701 DEVINE

PIGGIE PARK

DRIVE IN

(R-41)

SEE OUR AD UNDER CATERERS
BAR-B-Q PIT COOKED DAILY
SERVED FROM THE PIT
NO. 1 No. 2
POplar 5-2261 SUnset 7-9183
CHARLESTON HWY., W. COLA SUMTER HWY.

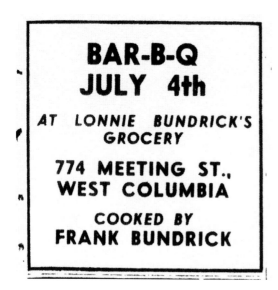

BAR-B-Q
JULY 4th

AT LONNIE BUNDRICK'S
GROCERY

774 MEETING ST.,
WEST COLUMBIA

COOKED BY
FRANK BUNDRICK

Another Lexington County man of German descent offered a Fourth of July barbeque at a kinsman's store. *Courtesy of the author.*

Of course, the telephone book and city directories were not the only ways to advertise. In 1935, we find that the Central Meat Market was still making barbeque, occasionally placing a small, one-column ad in the local newspapers on Tuesday stating that they would have barbecue on hand on Wednesday.

The surprising thing in going over these old newspapers is that the Varsity Grill on North Main Street consistently ran an ad for barbeque sandwiches in the late 1940s. It was a one-column ad, but it was two inches high, complete with a small graphic of a pig. The Varsity Grill was owned by Gus Capilos, who made the best Greek salad in South Carolina. Yet Gus found a market for barbeque sandwiches on a daily basis. Then, on July 4, the Varsity ran a larger ad announcing "Real Bar-B-Cue Pig" and hash, which was to be sold by the pound for takeout, not just for sandwiches. The fact that a Greek-owned restaurant was putting out pounds of barbeque on the Fourth of July was interesting enough, but there also had to be enough of a market for barbeque sandwiches to keep that Varsity ad running week in and week out.

Other than the regular Varsity ad, there were surprisingly few barbeque ads in the daily papers, except on those days that were holidays, when it was traditionally served. Frank Bundrick in Lexington County advertised for the Fourth of July, as did E.B. Lever, Adam Areheart and a handful of others.

The biggest effort, ad wise, was made by Adam's Camp, which was located out on the highway just outside of Columbia. The ad proclaimed that the road was now paved and that the owner had remodeled his restaurant and

The last line of the Adam's Camp Fourth of July ad bragged of its modern kitchen. *Courtesy of the author.*

installed "plenty of fans" (no air conditioning in those days). His ad pointed out that he was serving from a "stainless-steel kitchen." He also advertised that his restaurant could seat three hundred people and listed his Fourth of July menu as "pork, barbecue, fried fresh water catfish, hash, French fried potatoes, rice, coleslaw, dill pickles, red horse bread [as hush puppies were often called in those days], loaf bread, iced tea and coffee." Adam's Camp wasn't strictly a barbeque restaurant, but it was a sit-down restaurant that served barbeque on a regular basis.

E.B. Lever, who owned the first barbeque restaurant I remember from my childhood, bragged in his Fourth of July ad that he had been serving

BARBECUE

LEVER'S JULY 4th

PORK ● LAMB ● and HASH
READY JULY 3rd AFTERNOON

QUALITY is never an accident. It is always the result of intelligent effort. There must be a will to produce a superior thing; a clear conception of what quality is; a knowledge and skill equal to the purpose at hand; a willingness to test the product under any conditions. A standard of quality once attained must be held by a will no less firm than that which established it.

E. B. LEVER

PHONE 2-6278

E.B. Lever in West Columbia had his barbeque ready by the July 3 so that customers could get it the day before the holiday. *Courtesy of the author.*

Daily direct service between Columbia, Atlanta, Charlotte, Wilmington, Norfolk, Baltimore, Philadelphia, New York and intermediate points.

BARBECUE

JULY 4th

EDGEWOOD
METHODIST CHURCH
2229 Two-Notch Road
MEAT $1.25 Lb.
HASH 50c Pint

MAGNETO
AND
DIESEL

The people at Edgewood Methodist Church were capitalizing on the Fourth of July sales. *Courtesy of the author.*

The headline "Bar-B-Q Day" was bound to draw interested readers, as this insurance agency knew. *Courtesy of the author.*

barbeque for thirty-six years, although not all of those years were in a sit-down restaurant, of course. Indeed, most of that time, his operation was a stand, only later evolving into a sit-down eatery. And as expected, there were still multiple church groups providing barbeque for the holidays, still following the forty-year-old example set by the Shandon Methodists.

Just as a writer could mention the word "barbeque" and expect everyone to know what he was alluding to in the 1700s when he was actually discussing the custom of dueling (you will remember that he facetiously said he didn't want to kill a man in a duel even though a person might make a good barbeque), there was a general understanding that barbeque was expected on certain days, such as Labor Day and the Fourth of July. In 1947, Winchester Graham, who was in the insurance business, took out a large display ad with the attention-grabbing headline "Bar-B-Q Day," although what he was actually selling was insurance. Graham knew that people would read any ad that alluded to barbeque in its headline, so he was capitalizing on that ingrained interest in barbeque that Southerners have.

By the early 1950s, barbeque sellers at meat markets, takeout stands and those who set up for holidays, along with the few who were opening sit-down restaurants, had brought barbeque to the point that barbeque restaurants

could be open for more than two or three days a week. The real age of barbeque was about to be born.

Despite the fact that Columbia is actually located next to the epicenter of barbeque in South Carolina, which is Lexington County (more on Lexington County in Chapter Seven), it didn't have the barbeque activity that Charleston had in the 1920s to the 1950s. This is probably because Charleston has always had a much livelier restaurant scene.

There is a listing in the Charleston phone book as early as 1921 for a barbeque stand on Calhoun Street, and by 1931, there are three stands listed: the OK Barbecue Stand, located at 120 Meeting Street; Idylwild Barbeque Stand, with the address given as "8 Mile;" and the Pig 'N Pickle. The listings were, at first, included in a separate section of the Yellow Pages under the heading "Barbecue." However, most barbeque operations in Charleston soon started taking out their listings and display ads in the "Restaurants" section.

From 1931 to 1939, in either the "Barbecue" section or the "Restaurants" section, we regularly find the OK Barbecue Stand, Bootle's Barbeque Stand and the Idylwild Barbecue Stand. There was a Pig 'N Pickle selling barbecue in 1939, but it appeared to have gone out of business after just one year; however, there were others restaurants starting up in the 1940s. In 1942, Mother Kelly's Barbeque Stand, which gave its full address in the phone book as "Up King," opened up. By 1947, Mother Kelly was still operating, as was the OK Barbeque Stand, which had moved its listing to the "Restaurants" section, joined by Frank's Barbeque.

In 1948, two new barbeque operations opened up: the Roy Hart Drive-In and the Blonnie A. Rider Pit-Bar-B-Q Stand, which advertised its location as out on the "Dual Lane Highway." Unfortunately, the Blonnie Rider operation was gone in a year, but the Roy Hart Drive-In was much longer lived.

In 1951, the Rotisserie Diner and Tea Room opened and took out a nice display ad that noted that it "catered to the colored people of Charleston." In addition to being a sit-down restaurant, the Rotisserie Diner and Tea Room also offered private dining rooms as well as curb service. A sit-down barbeque restaurant for blacks was quite different from a stand. It's an interesting phenomenon that while whites and blacks couldn't sit down side by side in a restaurant due to segregation, there was complete eating equality if people were standing up. Given that adjustment to reality, barbeque stands could cater to both white and black patrons, and they did. Indeed, barbeque stands had both black and white owners and black and white pit masters,

The Roy Hart Drive-In did well for a number of years in Charleston. *Courtesy of the author.*

and all were frequented by anyone who wanted to buy some real pit-cooked barbeque.

It should be noted, however, that the restaurants in Charleston that advertised themselves as barbeque restaurants also seemed to have served fried chicken and seafood, as well as other items such as sandwiches or steak-and-chop dinners, depending on the clientele they hoped to attract. The Rotisserie Diner and Tea Room was certainly no exception. Seafood was expected in Charleston, and the fried chicken and sandwiches undoubtedly helped cover their bets.

The 1950s saw an explosion of restaurants and stands advertising barbeque as their main attraction in the Charleston area. In 1952, the "Restaurants"

Blonnie Rider started off with a big ad, but soon her restaurant stopped advertising. *Courtesy of the author.*

section of the telephone book listed the Turntable Inn; Bootle's Barbeque Stand; the Bar-B-Ranch on Folly Road; the Idylwild, still in operation; the Rotisserie Diner; and Red and Bertha's Drive-In. The "Barbecue" section listed the Pig Inn on Folly Road, joined by the hopeful Kream Kup, which must have been an ice-cream stand that also served barbeque sandwiches. In 1954, almost all of those places were still operating, as were the new Hickory Drive Inn on Rivers Avenue and the Smoky Pig Drive Inn, which listed its address as "Meeting Street Road."

In 1954, the Piggie Park Drive Inn took out its first ad in the Yellow Pages (it had opened about two years before) and was serving the Mount Pleasant area from 620 Rutledge Avenue. The restaurant had a large display ad that listed spare ribs for the first time in any ad. It was perhaps a bit confusing to Charlestonians, who had gotten used to looking up the Rotisserie Diner (whose ad had disappeared by 1954), because the stock graphic that the

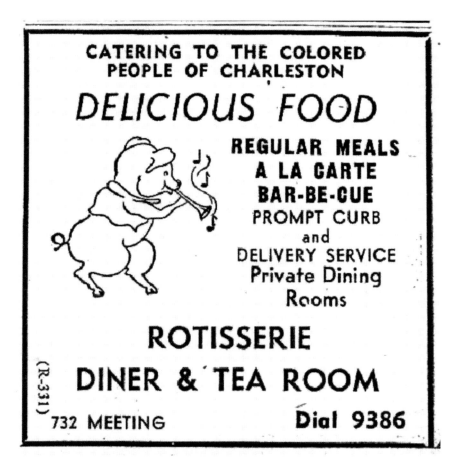

CATERING TO THE COLORED PEOPLE OF CHARLESTON

DELICIOUS FOOD

REGULAR MEALS
A LA CARTE
BAR-BE-CUE
PROMPT CURB
and
DELIVERY SERVICE
Private Dining
Rooms

ROTISSERIE
DINER & TEA ROOM
(R-331)
732 MEETING Dial 9386

The Rotisserie Diner & Tea Room advertised that it was "catering to the Colored People of Charleston" with its sit-down establishment. *Courtesy of the author.*

telephone company had used in the Rotisserie Diner ad, that of a pig playing a flute, was now being used in the Piggie Park ad. Regardless of what ad graphics it used, in just two years, Piggie Park went on to become the largest drive-in operation in South Carolina. Everyone was getting new cars in the 1950s, and curb hops were regularly in demand in the want ads, as drive-ins began popping up everywhere.

In 1955, the H&M Barbecue Grill on 200 Presidents Street opened up, and it was joined by Johnnies Barbecue and the Bar-B-Q Nook at 47 Morris Street. The Pig Inn was still on Folly Road, and the Smoky Pig Drive Inn was still in operation, as were most of those aforementioned restaurants. One big change was that the Rotisserie Diner was gone, but the Ebony Drive Inn

The Ebony Drive Inn was another establishment that served the black community with barbeque and other entrees. *Courtesy of the author.*

seemed to take its place in the black community. "Ebony" was often a code word for businesses that catered to the black population in the 1950s, and the address for the Ebony, 224 St. Phillip Street, would place it in a location that would have been convenient to black neighborhoods. Ebony's half-page ad was the largest that any operation had ever taken out in the restaurant section in Charleston, and while it actually showed a graphic of a chicken serving the customer and listed "Tasty, Golden Fried Shrimp" as its lead food, it also sported a large graphic of a pig and the words "Bar-B-Q Ribs." The Ebony also advertised free delivery.

In 1957, the H&M Barbecue Grill was still in operation, but it had been renamed the Cup 'N Saucer. But that wasn't the only change that year. Bootle's, which had been in the barbeque business since opening a stand on Windermere in 1937 and had already moved once, moved again to Highway 17 "opposite the Holiday Inn." Its one-inch ad advertised that it was "the ideal spot to meet your friends."

The greater Charleston area was more populous than the greater Columbia area, so it was able to support a larger number of barbeque restaurants. The difference was that in Columbia, there seemed to be a few more restaurants that specialized mainly in barbeque, whereas in Charleston, they always seemed to advertise both chicken and seafood as well.

Things were different in the upstate, however. In Greenville, Anderson, Easley, Spartanburg and other towns, there were few barbeque operations. In 1933, there were only fourteen restaurants listed in the Greenville telephone book, with no separate section for barbeque restaurants. The following year, the directory included a "Barbecue Stands" section with one listing: the College Inn at 215 College Street. By 1937, those fourteen restaurants had more than doubled to thirty-five. But there was still only one barbecue stand listed: the Colonial Sandwich Shoppe. By that time, the College Inn had quit advertising.

In 1950, Horton's Drive Inn took out a large display ad that proclaimed, "Barbecue is our specialty." Lawton Restaurant in the "Restaurants" section also advertised barbecue. However, in that same year, there were six different barbeque operations listed in the "Barbecue Stands" section—Barbecue Lodge, The Cricket, Cully's Drive-In, Powell's Curb Service, Sprad's Hi Hat and Whispering Pines—so there was plenty of barbeque to be had in Greenville. Another thing I found interesting was the fact that there were six different establishments selling barbecue while there were only four banks— there were more places to take care of your barbeque needs than your banking needs!

The Pig Inn was located on Folly Road for years and did a thriving business as a drive-in for the locals and in catching tourists on the way to Folly Beach. *Courtesy of the author.*

Opposite: Horton's was one of several Greenville restaurants offering barbeque as well as the usual chicken and steaks. It also let customers know that it was only "a 2 minute walk" from downtown. Presumably, it wanted walk-in as well as drive-in business. *Courtesy of the author.*

In 1954, Horton's was still listed under "Restaurants," but Lawton's and Sprad's had disappeared from the "Barbecue Stands" section. The aforementioned 1952 establishments were still in operation in 1954. But things were picking up in the barbeque world in Greenville in 1954. That year, D&W Manufacturing took out a listing in the "Barbecue Grills" section of the Yellow Pages offering commercial barbeque equipment, and Barbecue King first advertised its automatic barbecue machine.

When you go into your local grocery mega-mart and see chickens cooking in a large rotisserie, you are looking at a machine that was, I believe, first invented and put on the market in South Carolina. In 1954, Barbecue King put out a rotisserie that had three interesting features. The first was that it

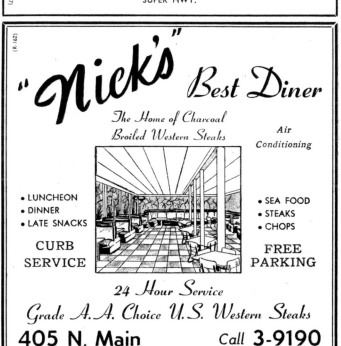

had a glass door that allowed the customer to get a glimpse of the miracle that was happening inside. The second feature was that the rotisserie was vented so that the customer would be enticed by the wonderful aromas that were issuing forth. But it was the third feature that was the killer. Barbecue King had come up with a way to insert a small, round piece of real wood (which they supplied with their machines), about four inches in diameter and one inch thick, that when heated to just the right temperature would give off a low smoke. The wood smoldered but did not burn. This aroma of wood and roasting chicken fat worked like a magnet in the stores that bought one. Barbecue King had hit the big time not only nationwide but also worldwide. The company's finest hour, as reported in the newspaper, was when that wonderful aroma was vented out over a street in Thailand, causing a riot as hundreds of Thais pushed and shoved each other to get into the store to find the source of that wonderful smell. The police had to be called. Apparently a good time was had by all.

Although a little bit of smoke to a roasted chicken does not a barbequed chicken make, it certainly does smell good, and it did the trick for the Barbecue King, just as it did for millions of happy housewives who found that they could take home a roasted chicken that was better (and almost as cheap) than the one she could cook herself. That wonderful hickory smoke even got to the people at Barbecue King so by 1958 that company had opened a drive-in called the Barbecue King Drive-In. By then, however, the company had a lot of competition. For the previous few years, the barbeque section of the phone book had been growing with the addition of Mandy's Drive In, Pine View Barbecue and Baby's Bar-B-Q Drive-In, while the Barbecue Lodge, Powell's, The Smoke House and others were still in operation. Even with all that competition, the Barbecue King Drive-In held out to 1962. Soon after that, the company gave up the retail restaurant business and went back to being the forerunner of today's rotisserie smokers. Southern Pride, Old Hickory and all of the other smokers that we have today can trace their lineage back to Greenville, South Carolina.

By 1962, barbeque restaurants and barbeque stands had actually diminished in Greenville. In the restaurant world, Greenville had become a steak-house town. Who knows, maybe all of those new Greenville millionaires, almost-millionaires and soon-to-be millionaires thought they deserved a big, thick, juicy steak for all of their business accomplishments. By 1963, there were only three or four restaurants, stands or drive-ins that bothered to advertise barbeque at all. Nevertheless, all across South Carolina, the stage had been set for the real coming-of-age of the state's—and America's—most famous native cuisine.

Chapter 5

BARBEQUE BECOMES
A CULTURAL PHENOMENON

If you look in the Yellow Pages under "Restaurants," you will find that various eateries are listed not only by location but also by the type of food they serve. The major breakdowns today, outside of the famous chains such as McDonald's, Subway, KFC and Hardee's, are categories such as "Italian and Pizza," "Chinese and Japanese," "American," "Seafood" and "Barbeque." There was a time when neither "Pizza" nor "Barbeque" was a category, but that was back in the 1920s.

Restaurants have been around for several hundred yeas in their present form. Some food historians say that restaurants first arose in Paris, France, and that they augmented the inns, cafés, taverns and boardinghouses that catered to the travelers. It is said that the word "restaurant" derives from a French word meaning "to restore." But for thousands of years, when people were away from their homes, they needed to be fed by someone, so some form of serving food for remuneration has been around forever. However, the restaurant as we know today it has made a steady transformation, especially in the last thirty years in the American South, where it has made not only a steady one but also a rapid one.

I remember when the smorgasbord, as it was first called, was all the rage back in the early 1950s. Smorgasbord was supposedly Swedish and often included, in the early days, some Swedish dishes, including Swedish meatballs and Swedish pancakes. In the South, however, the smorgasbord quickly gave way to a simple buffet line, which featured local favorites rather than those supposedly exotic Swedish offerings. Still, buffets would

not become common for quite some time. In the 1990s, a northern couple once asked me for directions as they were passing through on their way to Florida—they also asked me where they could find a Golden Corral. When I asked them why they would want to eat there, they got all excited about all the buffet items. They simply were not used to such a display of food back in New Jersey. I tried to steer them to a Quincy's, but they were accepting no substitutes.

However, most of today's buffet-style restaurants have evolved from earlier steak houses rather than from those aforementioned smorgasbord-style eateries. All of those steak houses that came along in the 1970s, '80s and '90s seemed to sport a Western theme, including the Ponderosa Steak Barn (taking advantage of a favorite cowboy television show at the time), Western Sizzlin' and, of course, Golden Coral. Quincy's and Ryan's, which were both founded in South Carolina, took the place of most of those Western-themed steak houses. Soon afterward, those remaining restaurants dropped their emphasis on steaks and went straight to buffets. In truth, buffets were not that common in either Chinese restaurants or barbeque restaurants in the 1960s, '70s and '80s. But with the increase in labor costs coupled with the decrease in food-storage costs and transportation costs, the buffet line became commonplace in the 1990s. Again, restaurants were evolving.

One day, Jackie Hite, of the famous Hite barbeque family that has called Lexington County home for generations, drove me around his hometown of Leesville, where his barbeque restaurant is located. Jackie's story is typical of the way so many restaurants got started in the South that it could be repeated in almost every Southern town.

That day, we drove by Jackie's childhood home. Leesville is so small that the residential section was only one block off of the main highway, SC 23, which goes through town from Columbia to Augusta. The house was located in a nice residential area with some large clapboard houses, most in the late Victorian style. "Right there," he said, pointing to an area beside a nice two-story house. "Right there behind that tree is where I ate my first barbeque. Daddy dug a hole in the ground and cooked a pig. I was about ten, and me and my cousin had a big time. We even got into a little of the moonshine. Daddy didn't know that. We were real excited; it was a big affair. My uncle, Uncle Tommy, daddy's older brother, was there. It was Uncle Tommy and Fate Anderson who taught Daddy how to cook a hog. They stayed up most of the night. The next day, all of the family came over to eat."

"What was the celebration," I asked.

"Oh, I don't know…just some family get-together I guess. I've forgotten."

We circled the block and were back on Highway 23. "Then when I was still ten, Daddy and Uncle Tommy and us boys helped cook a couple of hogs to get up some money for Tommy to go off to Newberry College. It was right there," he said, pointing to an empty lot behind what is now a store. "He went too, and he was All-American on the football team for two years." Jackie continued:

> When I was fourteen, there was a mule barn right there where those trees are now, and right in the middle of that lot—right where people turn around now—there was a pit. It was brick lined, but it was in the ground. If you wanted to work the hogs, you had to get down on your knees. Daddy and Uncle Tommy and us boys cooked a couple of hogs and sold the meat and hash to raise money for the fire department. My daddy was the fire chief back then, and he had the idea to raise some money. We sold out. Daddy gave us $10 each for helping them, and that was big money back in those days. Of course, we had to cut all the wood on Wednesday, the day before, and help cook all day. But $10 back then is like $100 today. We cut hickory and what I call black jacks. It went so good that daddy said we should have a Fireman's Ball the next year. So in 1950, I think it was, they blocked off Main Street, 'cause that's where the firehouse was then, right next to the town hall, and we cooked barbeque and chickens out back of the firehouse in a little shed that was back there. People came to dance right on Main Street and have supper. We had a band, and you could eat there or go around back and get barbeque or hash to take home. Some of 'em went back there to take a drink. They raised so much money that they did it every year for years—all the way up to 1975. Everybody came back then. We had a square dance, too, and a cakewalk. It was a big affair.

Jackie then drove me by an old building that was deserted even though it was on the main road, as so many old buildings are in these little towns. "Right there," he said, pointing to a little covered area that has lots of old furniture and junk in it. "That's where Daddy and I cooked barbeque to sell to people who wanted barbeque when the fire department wasn't selling it." He continued:

> Everybody couldn't get barbeque in those days; there weren't any barbeque restaurants. The only time you could get it was on holidays and such. Well, Daddy cooked some up and we sold it. We would wrap it up in paper for them, or they would bring a metal bucket, like a leftover lard bucket, and

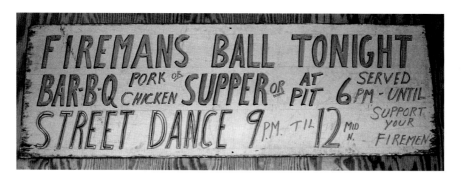

From the late 1950s up until the 1970s, the Leesville Volunteer Fire Department in Lexington County staged a "Fireman's Ball" each year. It was always a big success, with the whole town turning out to celebrate. *Courtesy of the Batesburg-Leesville Volunteer Fire Department.*

take it in that. And they would bring pint jars and quart jars, and you would see them standing in line with jars in their hands, waiting to fill 'em up with hash. Daddy ran a hardware store, too. But he cooked such good barbeque that one day, Albert Hartley, who's long dead now, said, "Why don't you cook up some 'que and sell it? People would come buy it if you cooked it." So we did. That's how we made a little extra money in those days. I was fire chief, too, back in the days after Daddy was. I was chief for ten years starting in 1966, and we keep on cooking for the Fireman's Ball and holidays.

You know, I always listened to my daddy. Everybody said he was the smartest man in town, and he was, too. One day, we were in the store, and he said to me, "Jackie, you ought to go right across the street there and open a barbeque stand. When people come to get barbeque, they pay you right then. It's not like this hardware business, where we're carrying everybody in town on credit." And we were, too. Sometimes we would have $25,000 or $26,000 on the books.

And I always listened to my daddy, so I opened a stand. First I tried to do it in a shed right down the road here. Have you ever seen where Shealy's got started? I'll show you. I rented that old shed from the Shealys. They said they couldn't make any money there, but I said I could. But I couldn't. So I moved to where I am now and opened a takeout barbeque stand. That was in 1979. Then when business got good, I enclosed it, and we started serving people at tables, too. But people still came for to-go orders. I added on that back part of the building in the 1980s, and I've been here ever since. You know, when Maurice opened his restaurant in Columbia back in

*the 1950s…that was a revelation. He was open every day. I didn't think
you could sell barbeque every day, but he did it.*

In addition to guiding me on that great barbeque tour of Leesville, Jackie
also opened up the Leesville Volunteer Fire Department's photo scrapbook
for me. That book contained lots of photos of the good people of Leesville,
who, over the years, put on their "Fireman's Ball," a very popular street
dance combined with a barbeque. Since Jackie's father was fire chief and
since he was an expert barbequer, he came up with the idea of having a
barbeque to raise money for much-needed equipment. At first, the Hites
and others got together and sold barbeque, barbequed chickens and hash.
Before long, that successful idea gave birth to the idea of expending it into
a party, dance and dinner for all of the town's people while maintaining the
tradition of having the barbeque for sale to take home if the customer just
wanted the food. But the good music and the camaraderie was enough to
cause hundreds of people to turn out. Before long, they added cakewalks
and other prizes, and for years, a good time was had by all. When Jackie Hite
replaced his father as fire chief, the department continued the Fireman's Ball
for years. It was finally discontinued when the pull of modern amusements,
television, movies, the ability to travel out of town for fun and the general
tone of life in the small towns changed.

Jackie's story is typical of so many others. He started out cooking for the
family and later began cooking for a civic group, helping him establish a good
reputation in the community. He then started to sell barbeque from a regular
location on the weekend to augment the family income, later moving to a
permanent location that everybody would call a "stand" and then converting
that stand into a sit-down restaurant. Hundreds of barbeque restaurants
got their start this way. Some flourished while the original barbeque cooker
was in charge only to go out of business when he died or retired. Many
restaurants were continued by sons and/or daughters, and some have even
been passed down to third- and fourth-generation descendants, a testament
to the quality and care that families put into their food and their restaurants.

In 1979, the Sandlapper Store in Lexington published *Hog Heaven: A Guide
to South Carolina Barbeque*. Allie Patricia Wall, a genuine barbeque devotee,
was the leading writer of that guide. I went through the index and counted
102 restaurants that were reviewed. In preparing this manuscript, I counted
47 of those restaurants that I knew were no longer in business. When you
consider that there had to be others on the list that I missed, we can safely say
that over half of the barbeque restaurants that were reviewed in 1979, only

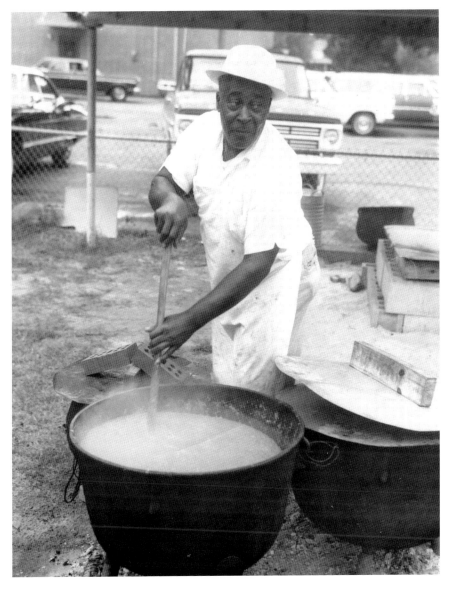

Bush Bundrick was not only a volunteer fireman but also a great maker of hash. *Courtesy of the Batesburg-Leesville Volunteer Fire Department.*

Opposite, top: Music was provided for the Fireman's Ball, and a street dance was the highlight of the evening. *Courtesy of the Batesburg-Leesville Volunteer Fire Department.*

Opposite, bottom: Fire Chief Jackie Hite cooked at the Fireman's Ball and would go on to open one of the most famous barbeque houses in the state. *Courtesy of the Batesburg-Leesville Volunteer Fire Department.*

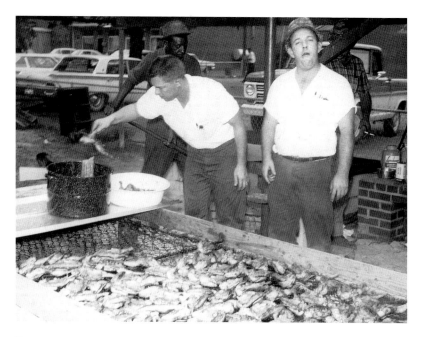

Both real barbequed chicken and barbeque were provided to the townspeople on the night of the Fireman's Ball. *Courtesy of the Batesburg-Leesville Volunteer Fire Department.*

All of the volunteer firemen and their wives were needed to get the barbeque ready for the ball, the town's biggest annual event. *Courtesy of the Batesburg-Leesville Volunteer Fire Department.*

thirty-four years before the publication of this book, were out of business. They were mostly out of business not because their barbeque was of poor quality but simply because the mom-and-pop aspect of the barbeque business caught up with the owners—they had simply retired as they aged, and there were no family members who wanted to continue that business. The good news is that despite the hard work that a restaurant imposes on the individual owner, about half of the barbeque restaurants that were open in 1979 are still open today, oftentimes going on into the third and even the fourth generation of the same family.

You may have noticed in the 1920s newspaper ads that many of the names associated with those early barbeques sellers were German: Dent, Hendrix, Lever, Kittrell and Slice, for instance. These families of German heritage were used to using their signature mustard sauce, and they were the primary barbeque cookers in the central South Carolina area all the way from Newberry down to Charleston. Those German families had been staging community cook-offs from all the way back to the time when most of them still spoke German. Indeed, it was as late as 1860, 125 years after they first came to South Carolina, that the Lutheran Synod in Columbia decreed that there were to be no more sermons preached in German in the Lutheran churches. The elders of the Synod realized that bringing the children up to speak only German was putting them at a disadvantage outside of the German communities. Given their common language and religion, those families were more inward looking than the English-speaking families, so they had a tendency to hold their get-togethers around their church or with their interconnected families. There were lots of old-time German favorites to be had at these gatherings—cured hams, fried and stewed rabbit (hasenpfeffer), sausages and brats, liver nips, turnip greens, sauerkraut, ginger bread and applesauce cake—but those slowly gave way to the dishes of the more numerous citizens of English and Scottish descent who lived nearby and who primarily set the cultural fashions. This gradual change in the eating habits of the German immigrants' descendants meant that barbeques became more common in the German area than it had been. The family gatherings and the church functions started having barbeques more regularly. Because the German families seemed to hold more of these types of gatherings, it was the families of German heritage that became the dominant barbeque cookers up and down the Saluda, Broad, Congaree and Santee Rivers—the areas that the German families had settled.

It is an interesting phenomenon that the Germans who came into South Carolina are from a different background than most of the other

German immigrants who came to the other colonies—and it was by design. South Carolina's Germans came in through a different process and a different seaport than the Germans who came to Pennsylvania and New England. The South Carolina Germans came by way of the port of Charleston in the mid-1730s. Starting in 1735, the colonial government of South Carolina, which then had its seat in Charleston, actively recruited German families to settle in South Carolina. They wanted those families to settle on the west side of the rivers so as to act as a buffer between the English settlers and the Indians. The Yamasee Indian War, the bloodiest Indian war in America, was a particularly brutal and nasty affair that saw nearly one in twelve of the white settlers in South Carolina killed. It had been only two decades before, in 1715–17, and it was fresh in everybody's thinking throughout the state—and certainly in the councils of Charleston. There were still Indian wars and skirmishes as late as the 1740s in the backcountry.

The colonial governor and the council, who had given it a lot of thought, decided that the Germans would make good colonists. They would be better than the Scots who did speak an understandable form of English and were Protestant but who wouldn't be caught dead inside an Anglican church. They were also the ancient enemy of the English, with the 1745 bloody battle of Culloden still ten years in the future. Additionally, the Scots had a tendency to make their own liquor rather than buy it from a good English merchant. The Germans were also a better choice than the French, who had two strikes against them as well. Like the Germans, they spoke a different language, but they were also overwhelmingly Catholic. The Germans couldn't speak English either, but they were Lutherans if they were recruited outside of the Catholic areas of Germany. Even though they were Lutheran and therefore couldn't hold public office in South Carolina as only Anglicans could in colonial times, the Lutheran Church was almost identical to the Anglican Church and much more in keeping with the English traditions than Roman Catholics would have been.

Thus, the powers that be in the 1730s saw the value of the Germans, as they were good farmers who practiced a different type of farming than did the English. The English were setting up plantations, which were actually a corporate type of farming in which they needed managers, overseers, accountants, factors and shifts of workers. The Germans farmed on smaller family farms, practicing a more intense style of farming given more to foodstuffs than large cash crops. The Germans were also known to be both neat and industrious.

The South Carolina colonial government actually sent people into Europe to recruit immigrants. They boated up the Rhine River, which is located on the western side of Germany and empties into the Atlantic through the Netherlands. This area in southwest Germany is called the Palatinate. In each little village and town, the recruiters would disembark and hold meetings in whatever public meeting place they could find. They also posted bills in public places to let the populace know that if they came to South Carolina, they would be given free passage and a free farm and they would be settled in a "township." Like any good salesman, they talked of all of the benefits of living in a place that stressed everyone making a living rather than everyone having to go to the very same church. They even had what we would call today a brochure to hand out. They somehow forget to mention the Indians.

The farm acreage the Germans would receive was to surround some newly formed townships. The idea was to have them live in a town, which was safer from Indian raids, from which they could leave at daybreak to work their farms, which were to be within walking distance. For the most part, the townships mostly seemed to carry English names, such as New Windsor and Amelia, but the Congaree Township had its name changed to Saxe-Gotha Township in 1735 to make the new Germans feel more at home. The idea of living in a town and walking out to the farm quickly broke down, however, and the German families began building their small log cabins on their farms and living there.

Tens of thousands of Germans came to South Carolina, usually with family in tow, and they brought their culture and habits with them. Along with their intense style of family farming, these new colonists also brought a loyalty to the Lutheran Church, their holiday traditions and their food ways. Two of those holiday customs were Christmas trees (rather than the English yule log) and the Easter rabbit and Easter egg hunts. Two of the food customs they brought were their love of pork and the use of mustard.

These Palatinate Germans were different from the Germans who came to the Mid-Atlantic, who generally came from Moravia or Bavaria or areas farther east of the Palatinate of Germany, so they did not generally use mustard. Germans in the 1700s were simply more diverse than the English colonials or even the English back in England. In that period, Germany consisted of nearly one hundred different principalities with their own prince or duke answering to a variety of kings. Their customs and foods were as different as Southern cooking is from New England cooking.

Since the Germans who migrated into Virginia and North Carolina generally did so by coming down from Pennsylvania, they brought different culinary customs with them. This is why the people of German descent in North Carolina (and many of them can be found in the piedmont of North Carolina, where barbeque is abundant today) use an entirely different form of finishing sauce for their barbeque than do the people of German descent in South Carolina. In other words, those two German traditions were, if not exactly a horse of a different color, at least a barbeque finishing sauce of a different color.

Over my lifetime, I've eaten barbeque in restaurants run by men with names such as Dunn, Fulmer, Hamm, Koon, Kyzer, Lever, Meyer, Mylander, Price, Roof, Seifert, Shealy, Shuler, Sikes, Sweatman, Wise and Zeigler, as well as six different restaurants run by various Dukes, ten restaurants run by different Bessingers and three different barbeque houses run by Hites. There was also a restaurant run by a Dooley, which is today's anglicized version of the German name Dula. (His mother, he confessed, was a Hite.) Then there are heaven knows how many restaurants that carry a name that doesn't give the owner's German heritage away, such as Pig Trail Inn or The Happy Pig, but from Newberry to Charleston, the majority of the barbeque houses generally have some connection with a German family.

Of course, the Germans were famous for their mustard sauce and their hash, but they were not the only barbequers in the state by a long shot. In the lowcountry from Little River to Savannah, with the exception of Charleston, which found itself at the end of rivers that flowed from German areas, the style of barbeque that predominated is what we call vinegar-and-pepper barbeque. This original style of barbeque, which dates all the way back to the Indians, uses both a vinegar-and-pepper basting sauce and a vinegar-and-pepper finishing sauce and is championed by the lowcountry people, who had a tendency to be either English or Scottish, or in the Pee Dee region, Welsh.

Today, the center of vinegar-and-pepper country is Williamsburg County, where the German names are few and far between. The names you see on the outside of barbeque restaurants there are McCabe, Brown, McKenzie, Moree, Cain, Scott and other obvious Scottish names.

One of the marvelous things about the Pee Dee barbeque tradition, even though it is a vinegar-and-pepper area rather than a mustard area, is that like the Germans, they have hash. Hash is misunderstood today by those people who have been unfortunate enough to have been brought up outside of a hash area, which is most of the country and even a large part of South

Carolina. Hash, which is looked down on by those who haven't tasted it, is nothing more than liquid sausage.

When making sausage, the meat is not cooked but rather it is removed from the bones and stuffed into casings. In the old days, the casings were made from pig intestines, but these have since given way to collagen-based casings or containers without casings. When a cook is making hash, there exists the same mixture of meats, fillers and some slightly different spices, but the meat is cooked in water. Then, after the meat is cooked, it is either ground up or pulled apart and then added back to the broth in which it was cooked, making the hash very much like a very thick soup. Hash, as I say, is liquefied sausage and if you like sausage (and who doesn't?), then you should like hash. The problem today is that people have gotten squeamish about their foods, and too many people are not even willing to try organ meats such as liver or belly meats or even ox tail or chicken gizzards.

Since organ meats were added to hash in the old days (and continue to be added to sausage today), people still think that hash is made that old-fashioned way. Given that bit of misinformation, many people are passing up a marvelous culinary experience because today almost no one in the old German areas uses organ meats anymore, instead using shoulder meats and hams. So today, millions of people happily eat sausage that contains parts of the pig that they wouldn't dare eat by themselves while turning up their noses at barbeque hash, which is made with nothing more than some lean beef, pork hams, pork fat and shoulders.

Fortunately for us, the barbequers in the Pee Dee area still carry on the old tradition of adding liver to their hash. One can still find a good liver hash from Dillon down to Kingstree on every buffet. In the Pee Dee, the barbequers, aware that there are modern-day misinformed eaters everywhere and that some of them do not eat liver hash also provide what they call a "red hash." While not really a hash, a "red hash" is nothing more than a thickened-up sauce. This is put over rice, much the same way gravy is. Sometimes, it's even called "red gravy." Quite frankly, a good sauce makes a pretty good red-gravy-and-rice dish.

Luckily for us, the modern-day demand for barbeque has spawned a whole new generation of barbeque restaurants, some of which follow, to a lesser degree, the Jackie Hite story told earlier. Remember that Jackie commented that when Maurice Bessinger opened his restaurant he didn't realize that people would come to eat barbeque seven days a week. That mindset was a holdover from the days when barbeque was served only on special occasions, family affairs and a few days on the weekend when people were beginning

Even though Joe Bessinger called his restaurant a "grill," his specialty was barbeque, and he taught this craft to all three of his sons: Maurice, Melvin and Thomas. *Courtesy of the Bessinger family.*

to get into the custom of going out to eat one meal per week. In 1954, when Maurice opened his first Columbia restaurant, most people were still used to eating barbeque either at special events or, at best, on weekends. A full-time barbeque restaurant open seven days a week was a rare bird.

Maurice's restaurant has a history of its own, however. Maurice's father, Joe Bessinger, opened Joe's Grill in Holly Hill, South Carolina, in 1939. Although he didn't call it a barbeque restaurant, Joe did cook and serve barbeque on the weekends, as well as a blue-plate lunch and dinner during the week. Mr. Joe, as most people called him, ran a tight ship. He didn't allow any drinking, even in the parking lot, and he didn't allow any rough language. He also taught his three boys the importance of hard work. The German heritage ran strong in the Bessinger household.

Joe's three sons are Maurice, the eldest; Melvin; and Thomas (known as "T"), the youngest. All three learned to make real barbeque while working with their father at Joe's Grill and at home, and all three went on to open their own barbeque restaurants. Melvin runs two barbeque restaurants (Melvin's) in the Charleston area: one in Mount Pleasant and one west of the Ashley on Folly Road. T's son, Tommy, runs Bessinger's, located on the much-traveled Highway 17 that parallels the coastline west

Joe Bessinger, the progenitor of the best-known barbeque family in South Carolina. *Courtesy of the Bessinger family.*

of the Ashley River in Charleston, and serves thousands of customers each week.

It is Maurice, however, who has brought more barbeque to more people in South Carolina than any other individual. It may very well be that Maurice has served more real barbeque to paying customers than anyone in the nation. I know of no other person who has more restaurants that serve real pit-cooked barbecue than Maurice. Indeed, he has fifteen restaurants in six different cities around the state. Despite his large operation, every morsel is cooked the old-fashioned way—low and slow over hickory coals that he makes himself. Maurice uses only fresh ingredients of the highest quality, a rule his father taught him, and he uses only hams for his barbeque and hash. He once even bragged that he used only left hams because the pig's right

ham is tougher, but today, his sons manage the business and use both left and right hams. Maurice was also putting out "all-natural" sauces long before the all-natural craze caught on with the public.

And while Maurice opened his operation, starting in West Columbia in 1954 in an old Zesto's ice cream stand he bought and converted, it was Melvin and Maurice together who opened the first Bessinger restaurant in Mount Pleasant in 1952. The drive-in became the highest-volume drive-in in South Carolina in a little over three years. Maurice and Melvin went their separate ways, and Maurice came to West Columbia and opened the first barbeque takeout stand (with curb service). That takeout stand would eventually become the largest barbeque empire in South Carolina.

Maybe it was the success of Joe Bessinger in Holly Hill, or maybe it was just happenstance, but in 1947, eight years after Mr. Joe opened Joe's Grill in Holly Hill, Harry Hite and his wife, Betty Ann, opened what we would today call a "convenience store" at the intersection of US Highway 378 and US Highway 1 in Lexington, South Carolina. It was a good location, at the convergence of two major U.S. highways, and it did well. Hite's store became quite popular, and what really made it so popular was that he was cooking barbeque out back in a special pit he had dug just for that purpose. His succulent barbeque soon became the main attraction, and in 1953, he tore down his store and opened a concrete-block restaurant, Hite's Barbecue Restaurant. At that stage, Hite was still cooking in his original pits, but modernization and increased demand dictated that he build larger indoor pits, which he did. In 1957, he installed electric heating for his new cookers, but he did put a big smoke box on it to give it that true smoky flavor. Hite's was a major draw as a sit-down restaurant, and you could eat there every day. When it was finally sold in 1996 to make way for a shopping center and giant CVS drugstore, it was the oldest restaurant in Lexington, having been open for nearly fifty years.

TIME OUT FOR HASH

For some reason, hash is almost unique to South Carolina—it's so good that one wonders just why other barbequers around the nation haven't adopted it. But other barbequers in most other states are latecomers to the art, and they didn't have the benefit of the aforementioned Palatinate Germans—that plus the fact that making hash is a long and difficult ordeal that takes a dedicated cook and staff.

As I said, hash is nothing more than liquid sausage, although it does not have the more distinctive sage taste that one generally finds in over-the-counter sausage brands. But again, hash is nothing more than meat boiled in broth and then either pulled or ground fine and mixed with spices and filler and then reintroduced back into the broth.

In South Carolina, however, there is a major difference in the way the meat is prepared for hash. In the area starting in Lexington County and moving toward the Georgia line, one can often find a hash called "string hash." In string hash, the meat is not ground but rather pulled, similar to pulled-pork barbeque. It is labor intensive and requires a trained hand, so as the older generations pass away, string hash is disappearing from the barbeque scene and is being replaced with the easier-to-make ground hash. It is much easier to run chunks of meat through an electric grinder than to stand there for a couple of hours and pull the meat chunks into finely pulled pork by hand.

Indeed, string hash takes about ten to twelve hours to make from start to finish. First, the pot has to be prepared for the meat, which is then cut up and cooked. This takes several hours. The pot then has to cool since the meat is too hot to handle. Next, the meat is taken out and pulled apart, and the fillers, usually onion and sometimes potatoes, are added. Spices are added according to the recipe that is being followed, but generally, the only spice is yellow prepared mustard. Despite the fact that there are dozens of different barbeque hashes in restaurants (and even some on the market), most of the hash that comes from the areas of German settlers tends to taste similar. In other words, the recipes don't seem to vary much. Then, after the meat has been cooked and prepared, it is added back to the broth it was cooked in, and it simmers for another four to six hours. The hash then has to be stirred almost continuously or it will scorch. The remarkable amount of work that goes into real barbeque hash, especially string hash, makes it a rare delicacy in most barbeque restaurants, and it is to be much appreciated when it is

String hash is the king of barbeque hashes because it involves so much labor to get it cooked just right. Notice the strings of meat on the edges of the paddles, which must be used to stir it constantly. *Courtesy of the author.*

available. One exception to this in South Carolina is the Orangeburg area, where a reddish hash is found. The color comes from their adding of a red sauce, or ketchup, to the hash recipe. Also, the meat is ground, not pulled. This hash can be found in a few restaurants outside of Orangeburg, but it is always being offered by someone who learned his craft in the Orangeburg area. I've heard some South Carolinians and some of the certified judges in the South Carolina Barbeque Association swear that Orangeburg-style hash is their number-one choice. And when you consider that tons of it are served every year in central South Carolina, there must be lots of other people who think so, too.

Today, the restaurateurs who take the time to serve hash generally make it in large stainless-steel vats. Of course that was not the original cooking method. Occasionally, one finds hash made in old cast-iron pots, and at Cannon's Barbeque in Newberry County, I came across just such a set-up. The hash was cooked not only in old cast-iron pots but also over wood fires, which lend a slightly smoky taste to the hash. This is the sort of attention to detail that real devotees to the art bring to barbequing. For the obvious reasons of time constraints and labor, most cooks now use a stainless-steel

Above: Today, most hash is cooked in large stainless-steel pots that are power stirred. *Courtesy of the author.*

Left: Jackie Hite insists that his hash be cooked the old-fashioned way in a large cast-iron pot. *Courtesy of the author.*

apparatus equipped with an electric stirring paddle. At Jackie Hite's in Leesville, they still use a very large, old cast-iron pot. Jackie is a traditionalist, as can be seen in the fact that he still serves string hash, with his wife being the chief puller in that labor-intensive task.

In South Carolina, hash is almost always served over rice, but rice is not the only thing that hash accompanies. I was once told of a well-known federal judge who sat on a district bench for decades who would often host a gathering of friends, fellow jurists and attorneys and always served hash at breakfast over grits. This popular judge hailed from Aiken County, where quality string hash was the norm. His hash-eating proclivity has to be tried to see just how good it really is. I'll admit that I was not raised to eat hash over grits, but once I tried it, it left me wondering why I had not thought of it myself. If we are going to eat ham with grits, bacon with grits and sausage with grits, then why not liquid sausage? Once I tried it, I realized it must have been a regular dish prepared in days gone by that has generally passed from our collective memory as we have gravitated away from our agricultural roots. A bowl of stone-ground grits topped with barbeque hash is a marvelous noonday or breakfast meal. Maurice Bessinger, who maintained a trim physique all of his life, often had a bowl of rice and hash along with a glass of tea as his noonday meal.

In the Pee Dee region of South Carolina, one also finds hash on all of the barbeque menus and buffets. There is no German tradition in the Pee Dee, so this hash had to have had a different origin, certainly dating from the 1700s and 1800s, when that area was settled. Regardless of its origin, they still do one thing there that is fast fading from the barbeque scene: they add liver to their hash (even if they are using mostly chicken livers rather than pork livers).

Since traditional hash is much to be desired and is gradually leaving the scene, I felt it prudent to include a recipe for hash. Be cautioned that I Googled "SC BBQ hash" and found a large variety of hash recipes that were, obviously, made up by people who knew nothing about real barbeque hash. Any recipe that has carrots, lemon slices, chicken and other assorted ingredients is to be avoided if you are looking for authenticity. The following recipe is taken directly from Jackie Hite's restaurant in Leesville. This recipe is the real deal, and it needed to be recorded somewhere before Jackie passed away.

Old-time String Hash Recipe

Makes 200 quarts

Fill about one-third of a 78-gallon cast-iron pot with cold water.

Add to pot:

25 pounds of jumbo yellow onions, quartered
65 pounds of chuck roast beef
60 pounds of pork shoulders, no bones
20 pounds of hog jowls
The trimmings (fat meat from cleaned pigs) of four
 hogs, which is about 10 more pounds of fat pork.
Three "handfuls" of salt (about 1 ½ to 2 cups).
 "You can add more later if you want," says Jackie.

- *The meat has to all be cut up into about three-inch cubes.*
- *Cook four and a half to five hours, stirring constantly. Then let cool.*
- *Take cooled meat, place it on a large table and pull it apart until consistency is fine. This takes about two hours if you're good at it.*
- *Clean the pot and put everything that has been pulled back into the pot. Cook for five to six more hours, stirring constantly, and add 8 gallons of mustard (Wood Brothers from Lexington).*
- *Add 1 cup of ground black pepper.*

While the above recipe is of both historic and culinary interest, if you want to make hash, you probably don't want two hundred quarts. The recipe below was worked out from the one above and adapted a bit by Morry Thomas, a Master Judge in the SCBA, and George King, who is a two-time holder of the South Carolina State Barbeque Championship.

Courtesy of the author.

HASH

3 POUNDS PORK SHOULDER

3 POUNDS BEEF CHUCK ROAST

3 MEDIUM ONIONS

1 CUP SOUTHERN GOLD (MUSTARD-STYLE) BBQ SAUCE

Maurice Bessinger has a recommended sauce at Piggy Park

½ CUP APPLE CIDER VINEGAR

⅓ CUP CATSUP

⅓ CUP YELLOW MUSTARD

⅓ CUP WORCESTERSHIRE SAUCE

1 TABLESPOON KITCHEN BOUQUET

1 TEASPOON CAYENNE PEPPER

1 TEASPOON BLACK PEPPER

1 TEASPOON SALT

1 TEASPOON OLD BAY

½ TEASPOON ACCENT

- *Cut pork and beef into two-inch cubes and rough chop onions. Put meat and onions in pressure cooker with at least two cups of water. Bring to pressure and let cook for 20 minutes.*
- *Release steam and strain meat and onions while reserving liquid.*
- *Grind cooked cubes of meat along with onions through a food grinder with a medium grinding plate. Grinding is important to the texture, as a food processor or blender will liquefy the meat if not careful.*
- *Ground meat is returned to a cooking vessel along with the spices, sauces and other ingredients EXCEPT the vinegar, which is reserved for the end. Add in reserved cooking broth as needed to achieve the consistency that is liquid enough to stir easily but not overly watery or soupy. When served on rice, the consistency should be just firm enough to sit atop the rice without running on the plate.*
- *Add the vinegar a little at a time until you achieve the desired taste. Add more beyond the ½ cup if desired. Adjust salt at this point.*
- *Serve on hot white rice as a side dish, or if you love this hash as much as I do, this will be my main dish. Makes about ¾ gallon.*

Chapter 6

MODERN-DAY BARBEQUE

For years, I jokingly told people about "High's First Law." It is a simple law, and it goes like this: "Everything gets worse." I then went on to name a few things that have gotten worse—things that no one can argue with: Washington, the local government, television programs, movies, roads and highways, taxes, schools, my back pain, kids' behavior, inflation. The list is endless because it seems as if everything does indeed get worse every year. Then, one day, I thought of an exception to my law: wine.

As an American Wine Society Certified Wine Judge, I've gotten to judge wine over several decades, and my hands-on tasting, so to speak, goes back to when I started my own wine cellar over forty-five years ago, way back in 1967. But over the years, I noticed that wine was getting better, and not just some better, but a lot better.

The new temperature-controlled fermentation process pioneered by the University of California at Davis has wrought a revolution in hot wine-growing climates such as the south of France, the south of Italy and Spain. Before refrigerated fermentation was instituted, the wines coming out of those hot regions were, at best, barely drinkable. In the wine trade, the wine from these areas was called "plonk," a name that gives some idea of just how bad it was. But UC Davis changed all that, and today, the south of France and especially Spain produce some of the world's great wines. For the wine consumer, the great thing is that given their centuries-old reputation for bad wine, modern-day prices haven't yet caught up with their new quality, so those hot southern areas are the places to look for good wines at bargain prices.

And refrigerated fermentation isn't the only wonderful thing that has happened to wine. With more and more vintners now making drinkable wine, there is more wine on the market, driving down prices. In addition to being better than it used to be, wine is also cheaper than it used to be, even when you adjust for inflation. When you look at the broad picture, we are in a golden age of wine, and the same can be said of barbeque. So, as it turns out, High's First Law has exceptions.

Now, I'm not saying that the properly prepared barbeque you had as a kid at the church picnic wasn't wonderful. What I am saying is that there was never a time when you could walk into a restaurant seven days a week and get real pit-cooked barbeque in so many places at such a low price. There are so many choices now that everyone can have favorites. We can now pick and choose where we want to get our fill of different styles of barbeque, whereas only forty years ago, we had only a fraction of the number of restaurants that are available today. Plus, in South Carolina, the nation's true barbeque state, we have more barbeque cook-offs in our towns and cities on a per capita basis than any state in the nation. The South Carolina Barbeque Association judges between thirty and forty cook-offs each year, and other sanctioning bodies, such as the Kansas City Barbeque Society, sanction several more. Almost every weekend sees anywhere from fifteen to eighty or more barbeque teams vying for trophies and cash prizes. At these events, the public can come and eat their fill of championship barbeque. Then there are also the independent barbeque events hosted by local churches, men's lodges, volunteer fire departments and many other organizations. Add it all up, and there is hardly a weekend outside of the dead of winter when there isn't at least one barbeque cook-off going on somewhere in the state. Oftentimes, several barbeque cook-offs will be held in different towns on the same weekend.

Then there is the quality of barbeque in this golden age.

At any given time, there are over 250 teams in South Carolina cooking in one competition or another several times each year. The cook teams on today's barbeque circuit are turning out a product that is better than ever, and if you ask these team captains, they will tell you that all these competitions over the last several years have sharpened everybody's talents. By promoting so many cook-offs, the SCBA has improved the quality of barbeque in South Carolina in the short time since its founding in 2004.

There is also a new awareness of barbeque among restaurant owners. Just ten years ago, if you went into a barbeque restaurant, they would have their one house sauce either on the table or on the buffet line. Now when

you go into a restaurant, there will be two, three and sometimes even four different sauces on the table. This awareness of different sauces found around the state is directly traceable back to the SCBA's efforts to educate its judges and the public that South Carolina is the only state in the nation that has historically had four different sauces. Those sauces, by the way, are the original vinegar-and-pepper, the historic mustard, the light tomato and the sweet, heavy tomato sauce, which is relatively new. Restaurant owners, aware that people like different finishing sauces to adjust the flavor of their barbeque, have started making different sauces readily available.

As we advance into this new golden age of barbeque, it seems as if the number of restaurants that turn out real pit-cooked barbeque has dropped in the last forty years. That is an illusion. The truth is that all real barbeque houses are mom-and-pop operations, so they do come and go. Everybody has a favorite restaurant that they used to go to that is no longer in operation, so it's natural to lament their passing. But in truth, there were not that many real barbeque restaurants before 1960 where a person could get barbeque regularly—and certainly not seven days a week. So while everyone has lost their "favorite" barbeque restaurant, there is another (maybe even two or three) that has taken its place.

The "pit-cooked" aspect of the equation is also a bit illusory. As the old-time barbeque houses, the family-owned favorites we all had, were closing down or were being passed down to sons and daughters, the newer generation had a tendency to convert the wood-fired pits to gas pits. The reason is simple: wood takes lots of work and skill, while gas is easy. So for years, as one great barbeque house after another passed into new hands, the quality dropped, and it became a regular thing to bemoan the passing of something great.

But then, as things were getting worse, a wonderful thing happened. Into the pit-cooked void stepped free enterprise; that is, someone invented a commercial cooker that used real smoke and the heat from wood to augment the gas flame used as the primary source of heat. In those commercial cookers, the automatic thermostats keep a low, steady, supplemental heat provided by gas, but there is also a "smoke box" attached, in which wood can be burned. The smoke and the heat from that wood is forced into the pits so that the meat, when it comes out ready to be served, can hardly be distinguished from that which was cooked in real pits years ago. People tell me they can taste the difference, but in most cases, they are simply remembering it incorrectly. In days gone by, most barbeque was cooked "whole-hog"; that is, the entire hog was cooked, and the meat was cut off

Bessinger's Restaurant on Savannah Highway in Charleston. *Courtesy of Chad Rhoad.*

Home Team BBQ in Charleston is one of several lowcountry restaurants that cooks with vinegar-and-pepper sauce. *Courtesy of Chad Rhoad.*

Gene Culbertson II is head cook and pit master for Backwoods Bar-B-Que, one of South Carolina's many competition grilling teams. *Courtesy of Chad Rhoad.*

The South Carolina Barbeque Association sanctions many cooking competitions in which guests get to sample barbeque from many of the area's cooking teams. *Courtesy of Chad Rhoad.*

Above: Fatboy's Barbeque is a competition barbeque team and catering business from Greenville. *Courtesy of Chad Rhoad.*

Left: Inspired by a trip to Las Vegas, the unique sign at Piggie Park in West Columbia is the largest barbeque sign in the state. *Courtesy of Clarissa L. Johnson.*

Barbeque hash is pork (sometimes beef) with added spices and "fillers," which are generally onions and potatoes. Some cooks add peppers and other tasty vegetables according to their own recipes. *Courtesy of Clarissa L. Johnson.*

Opposite, top: Today, barbeque hash is generally made in large, automated stainless-steel vats. It's rare to find hash made in old cast-iron pots the way our ancestors did. *Courtesy of Clarissa L. Johnson.*

Opposite, bottom: Paul Bessinger, who works as a pit master and also performs managerial duties, is the third generation of Bessingers in his family's large barbeque business. The Bessingers, who are South Carolina's first family of barbeque, are now in their fourth generation, and they show no signs of slowing down. *Courtesy of Clarissa L. Johnson.*

When asked what their favorite barbeque is, almost everyone says ribs, and there is a reason why: the ribs are the most tender and flavorful region of the pig. *Courtesy of Clarissa L. Johnson.*

The first barbeque buffet was probably opened at Shealy's in Batesburg-Leesville in 1969. Since then, South Carolinians have seen all-you-can-eat barbeque buffets multiply to the point that mounds and mounds of tempting barbeque are available seven days a week. *Courtesy of Clarissa L. Johnson.*

The cooks at Shealy's prepare the food for the day. *Courtesy of Clarissa L. Johnson.*

Barbeque buffets can be found all over the state of South Carolina. *Courtesy of Clarissa L. Johnson.*

Today, ribs are usually prepared separately from the pork, which is generally cut into hams and shoulders. This is because 150-pound hogs are too much for most restaurants to handle. Nevertheless, preparing ribs the right way, as these pit masters at Jackie Hite's are doing, is hard work. *Courtesy of Clarissa L. Johnson.*

Stainless-steel hash pots are the norm today, except in a few places where the pit masters insist on making it the old-fashioned way, as Jackie Hite is doing in his restaurant in Batesburg-Leesville. *Courtesy of Clarissa L. Johnson.*

Today, most barbeque is cooked in stainless-steel rotisserie machines with attached smoke boxes. But some restaurateurs insist on old-style pits and even make their own coals from hickory and oak, as seen here. *Courtesy of Clarissa L. Johnson.*

Hash used to be made with organ meats, but today, only prime hams and shoulders are cut up for hash—except in those few lucky cases where some liver is added. *Courtesy of Clarissa L. Johnson.*

Above: On the grill at Hite's in West Columbia. *Courtesy of Clarissa L. Johnson.*

Left: A look inside the pit. *Courtesy of Clarissa L. Johnson.*

Left: An employee of Little Pig's in Columbia refills the buffet. *Courtesy of Clarissa L. Johnson.*

Below: A heaping helping of South Carolina barbeque. *Courtesy of Clarissa L. Johnson.*

Above: Little Pig's Barbeque in Columbia. *Courtesy of Clarissa L. Johnson.*

Left: A customer enjoys the delicious food at Little Pig's. *Courtesy of Clarissa L. Johnson.*

Two decorated pigs at Hudson's Smokehouse. *Courtesy of Clarissa L. Johnson.*

Hudson's Smokehouse in Columbia. *Courtesy of Clarissa L. Johnson.*

Hudson's Smokehouse in Lexington. *Courtesy of Clarissa L. Johnson.*

In some restaurants, sides such as fried potatoes, sweet potatoes and macaroni and cheese have become staples, but pulled-pork barbeque, hash over rice, slaw and bread still remains the classic South Carolina barbeque dinner. *Courtesy of Clarissa L. Johnson.*

A look at some of the succulent ribs available at restaurants all over the state. *Courtesy of Clarissa L. Johnson.*

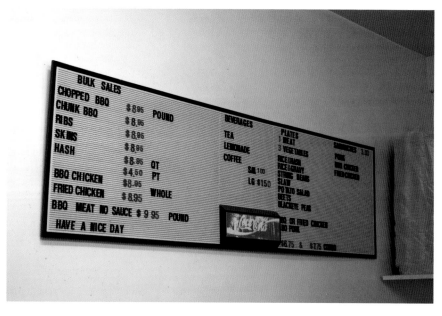

This is the type of sign that can be found at barbecue buffets across South Carolina. *Courtesy of Clarissa L. Johnson.*

of the bones. Whole-hog meat tastes different from the butts and hams that most barbeque houses now use as their basic meats. Many restaurants use these smaller cuts of meat because 10-pound hams and shoulders are easier to handle than a 150-pound hog. Additionally, they do not have to remove the meat from the bone, and unlike whole-hog barbeque, there is no waste. But with whole-hog barbeque, which has bubbled along in all of that fat and bacon for a dozen or so hours, the taste is better than that of the meat pulled from butts and hams. That is what most people are missing now—the type of cooking that imparts a different taste. Unfortunately, there is not much of a cure for that taste difference today.

It is so much easier to let a new stainless-steel pit with an automatic thermostat keep just the right amount of heat on all the time than to keep shoveling coals hour after hour. The good thing, as I mentioned above, is that the new smoke boxes that most of these new pits contain add just the right amount of smoke to the meat to give it that taste that all real barbeque has to have. In fact, as most old-time pit masters know, the meat is going to absorb all the smoke it can take in only about five hours. They can cook it on low heat for ten hours or so and smoke it for five hours or so, and it is a rare person who can distinguish it from barbeque cooked over an old-fashioned pit.

There is another phenomenon going on that has affected the number of barbeque restaurants. More and more people are taking their second and third meals outside of the house than ever before. There was a time when the businessman took his lunch out of the house either in a restaurant or by bringing his own lunch box, but back at home, breakfast and supper were almost always eaten with the family. Since it now takes two incomes to run a household—one to support the family and the other to pay the taxes—the ladies have found themselves working outside of the home and inside of it as well. Rightfully, the ladies have asked for some relief from having to work all day and then hit the kitchen the minute they get home. Hence the rise of not only more and more processed foods available in the supermarkets, which one has to only heat and eat, but also more and more families going out to eat.

There is one blight on the golden age of barbeque, however, and that is in the area of barbeque that is available in grocery stores. There are plenty of these products in our stores, and they are beginning to multiply as more and more people want barbeque that they can take home for supper. There are several suppliers that offer real hash in South Carolina that one can buy in one-pound containers, but you will note that all of them call it hash, not barbeque hash, which would be a traditionally correct term.

Many large grocery stores in South Carolina carry one-pint containers of hash in their frozen-food sections.

Opposite, top: Today, very little of the so-called barbeque found in large stores is real barbeque, as health departments all over the South have decreed that any commercially sold barbeque must be cooked in stainless-steel pits. *Courtesy of the author.*

Opposite, bottom:If you read closely the writing on the barbeque that is being offered in large stores, you will note that those products are advertised as "cooked pork" or "roast pork" or "pulled pork" with "barbecue sauce." *Courtesy of the author.*

On the other hand, if you read the labels of the so-called barbeque containers, you will note that they all say, in one form or the other, "pork with barbeque sauce," because the modern-day health laws in most states will not allow real pit-cooked barbeque to be sold in stores. They used to allow it, but no longer. The national golden standard for this used to be Maurice's real barbeque, which was all pit-cooked over real hickory wood. When that was allowed, people in South Carolina and neighboring states could get real one-hundred-mile barbeque simply by visiting the frozen-food section of their local supermarket.

But as the health mavens have increased their hold over our foods, they have taken the steps that have caused only pork cooked in "proper" vessels

and in approved kitchens to be sold in stores. Unless the barbeque is cooked in a stainless-steel pit, of which there are hardly any in existence, it can't be sold in stores. Therefore, the sellers of today's product have been forced to call it by its real name: pork. To lure the customer in, they generally use the word "barbeque" for the sauce, displaying that word in large letters and "pork" in much smaller print on their advertising.

Another way the golden age of barbeque has affected the nation is that there are now numerous TV shows on every aspect of the subject, from its preparation to the festivals and cook-off competitions.

There are hundreds of barbeque competitions all across the nation, with cook-offs being endemic across the South and moving into other regions as well. A good number of barbeque contests are covered by one television show or another, and each one helps promote barbeque in general. In South Carolina, the Tastes Show held a competition between the top ten teams in South Carolina as determined by a yearlong contest that covered 150 teams in over thirty different venues. The top ten teams had proved their mettle to say the least, as South Carolina was the only state in the nation at that time to hold such a long, grueling contest to determine who the top teams were. (Several other states have now adopted that yearlong method of determining who their top teams are.) At the Taste Show, Chef Aaron McCargo of the Food Channel was the honorary judge, sitting alongside other trained SCBA judges. It is this type of event, televised across the nation, that helps insert barbeque into our daily lives.

While national television is replete with cooking shows and travel shows that feature barbeque, some local television stations have also hopped on the barbeque bandwagon. A few years back, WISTV, an NBC affiliate in Columbia, did a series of four shows on a few select barbeque houses that they asked me to pick out from those that were in their viewing area. I chose Hite's in Leesville, Schoolhouse in Scranton and Myers in Blythewood. The producer at WIS wanted to add Hammy's in Elgin to the list, and I agreed. On four successive weekly Friday nights, the station carried its crew and equipment to these four restaurants and broadcast live as select judges talked back and forth among themselves and judged the barbeque. The judging was done in a light, good-hearted manner since the restaurants had been pre selected, and there was never any doubt that all of them would be rated highly by the guest judges. To lend an air of credibility to the judging, WIS wanted one certified judge from the SCBA to also sit in at the judging.

Chef Aaron McCargo, who starred on the Food Channel, was the honorary judge for the Taste Show in Myrtle Beach. The winner of that best-of-the-best contest was Brian Teigue of Rock Hill (far right), who cooks with his wife, Sherry, on a team they call Up in Smoke. *Courtesy of the author.*

The WISTV show that was done at McCabe's, a one-hundred-mile barbeque house in Manning, was seen by the locals, one of whom happened to be famous New York Yankees second baseman Bobby Richardson. Senior judge Bill Barksdale was joined in the judging by TV personalities Joe Pinner and Ben Tanner, who is on the right in this picture doing an impromptu interview. *Courtesy of the author.*

WISTV in Lone Star saw SCBA master judge Bronnie Smith join TV personalities Joe Pinner and Hannah Horn. Judi Gatson, the hardworking WISTV anchorwoman shown on the right, led the discussion of barbeque and side dishes. *Courtesy of the author.*

The first series of four programs was so successful that the executive director of WIS got in touch with me and asked me to recommend four more restaurants. He told me that WIS had never received so many complimentary letters and emails from viewers on any program they had ever done. He was so impressed that he came out to watch one of the broadcasts. The second group of restaurants included Lone Star in Santee, McCabe's in Manning, Good Lands in Springdale and Wise's in Newberry, as that station had received a large number of recommendations from the people who lived in that area.

There are also several newspapers that now serve the barbeque scene, with the *BBQ Times*, out of Rome, Georgia, and *National Barbecue News*, out of Douglas, Georgia, being just two of the most prominent. And there is also the *Bull Sheet*, the newspaper of the KCBS, which is a large, well-done monthly newspaper.

Another thing that has made this the golden age of barbeque, at least in South Carolina, is the South Carolina Barbeque Association. The judging always comes first with the SCBA, and efforts have truly been made to make South Carolina judges the best in the nation. First of all, if one is going to be a judge in South Carolina, he or she has to be prepared to taste a variety of barbeque styles. In South Carolina, our barbeque diversity demands that

a judge be able to put aside any personal preference or bias and be prepared to look at all barbeques with an open mind. To become a certified SCBA barbeque judge, one must first attend a seminar that lasts most of the day. He or she then has to apprentice under the direction of a master judge at four different cook-offs before being made a certified judge and allowed to give out scores to cookers.

The major difference in the South Carolina approach and the others that are used around the nation is what is called "pairwise comparison." Pairwise comparison is simply comparing one sample of barbeque with another. Actually, I shouldn't say "simply" because there are some rules and approaches that should be used in pairwise comparison that no other judging operation in the nation uses. First of all, with the very first sample that a judge gets from the receiving table, there is nothing to compare it with. It's the first one on his tasting mat. The judge has to compare that sample with all of the other barbeque he has had in his lifetime, of which he carries a profile in his memory. It is only with his second sample that he can compare the first. The third sample is compared with the first two, and so on.

You may think that because this method is so simple, every group employs it, but you would be very mistaken. In the Kansas City Barbecue Society (KCBS), for instance, their judges (of which I am one) are told to disregard all other barbeques on the mat and judge each one individually "without comparing them with any other barbeque." They instruct the beginning judge to think of it as a grammar school true-false test and to go with his first impressions. The judge is stuck with his first impression regardless of any change of mind he might have; he cannot change his first score. This method of not changing one's mind and not comparing a sample with any other sample that one has in front of him or which he may have had in his lifetime is simply not realistic.

In the SCBA, all of the judges are given a pencil with an eraser rather than an ink pen. They are told that they can alter any score they have given after they have run pairwise comparisons. That way, the judge's final score is his best thinking, and he has given each sample several chances.

The Memphis Barbecue Network (MBN), of which I am also a certified judge, has another approach. At its judgings, the judge is given three samples each of three different meats: pork, chicken and ribs. Each entry receives a numeric grade based on a scale that runs from five to ten. The real problem with the MBN system, however, is that out of each three entries the judge receives, he must give a score of ten to one of them.

During the training class, I raised my hand and asked the instructor what I should do if all three samples were "unimaginably awful" and I thought they all deserved the lowest score of five. He laughed and said, "Well, one will be slightly less 'unimaginably awful' than the other two, and that one gets a ten." Essentially, one out of every three barbeques that is submitted to the MBN rates a perfect score. In the SCBA, I've seen a perfect score turned in less than two dozen times over thousands of entries in hundreds of contests. In truth, the MBN system is just not as good as the SCBA system, which is much more realistic.

Of course, you don't have to be a trained judge to know good barbeque when you taste it. Every South Carolinian has grown up in a culture in which barbeque is present. Over the years, you have come to develop a taste for what you like and what you don't like in barbeque. The marvelous thing about living in the nation's best barbeque state, however, is that you readily get to try various sauces and various styles of barbeque that are denied to most of the people in the rest of the nation. In most areas of the nation, it's a Johnny-one-note existence in which barbeque is distinguished pretty much by the talent of the cooker. And while the talent of the cooker is also paramount in South Carolina, here we also get variety in types of barbeque and flavor profiles.

As mentioned in previous chapters, there must have been tens of thousands of backyard barbeques all over the South, all the way from the 1600s up to today. Everyone knew what the word "barbeque" meant, yet due to a number of factors, the recording of the backyard barbeque is rare. First of all, in the 1700s and early 1800s, no one had a camera. Even in the 1950s, cameras were still a bit rare in families and were only brought out for special occasions such as Christmas or Thanksgiving. Today, however, every young person has a camera phone right in their pocket. Also, for some reason, a picture of such a mundane thing as a hole in the ground or a makeshift backyard pit was not generally thought of as worthy of film. This combination of factors has left us with few pictures of backyard barbeques, despite the fact that probably hundreds of thousands of them have taken place over the centuries.

In asking for some remembrances of old barbeques, I did uncover one that has been published by Edna McDaniel Huggins of Hemingway, South Carolina. (Note her Scottish maiden name in that Scottish area of vinegar-and-pepper barbeque.) Mrs. Huggins was kind enough to send it to me, and it has been retyped just as she wrote it:

Pit Cooked Bar-B-Q
As Edna McDaniel Huggins Remembers

When my daddy, Cape McDaniel, decided it was time to barbeque, he would begin preparing days ahead. There was a dirt pit behind our house, and it always needed cleaning out, as leaves and trash would accumulate from cooking to cooking. We children—Katherine, Edna, Lena, Norman, Willis and Andrew—helped in cleaning out the pit. Dad would haul his wood and kindling for the fire, which produced the coals that cooked the pits. Using a piece of panel wire to cover the pit, he would anchor it on each side of the pit with stakes. His first pit was big enough to cook two pigs. Later, he enlarged it to cook four pigs at a time.

Dad butchered pigs himself until the locker plant opened in town. Then he would take them there to be butchered. Dad would buy all this "stuff for sauce" and mix it himself. Mom, Edith Hughes McDaniel, always made Dad a sauce mop by tying a clean cloth to the end of her wooden paddle. When it was time to turn the pigs, he needed help, and Davol Davis was always there to help him. Then he would start mopping the pigs with the sauce using his "special mop," and after 10 to 12 hours of slow cooking, the meat was "ready to pick."

We always had barbeque on Thanksgiving Day because we had the McDaniel family reunion each year at our house, since it was the "Home Place." Dad would bring tables from the tobacco barn and place them end to end in the back yard. Mom would cover them with white tablecloths. Everyone would bring covered dishes, and everyone (from 50 to 100 people) would have a grand day. This was truly a day for Thanksgiving, with both family members and many non-family members present. As far back as I can remember, until the reunion was discontinued, it never "rained out" our dinner in the yard.

I, Edna McDaniel Huggins, along with Lena and Kathryn, my sisters, would be busy helping Mama, cleaning house, picking up all the pecans so they wouldn't be run over, ironing tablecloths. And, of course, I was always busy seeing about everyone else's business and getting whippings.

—*Edna Huggins, Hemingway, SC*

Edna Huggins's experience was exactly the same as my first backyard barbeque at my grandmother's. The dirt pit, the whole pig slowly cooked over self-made coals and mopped with a sauce put on with a cloth mop on

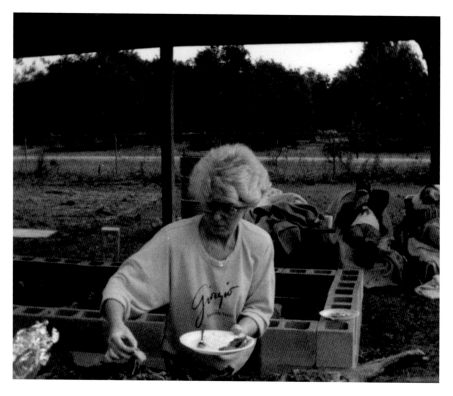

Marylee Powers, a Huggins family member, is seen here helping herself at a family reunion barbeque. Note the newly stacked concrete-block barbeque pit in the background. *Courtesy of the Huggins family.*

a long wooden pole. That has to be exactly as it was all over the South for generations. Then, sometime in the 1950s, people seemed to evolve past the pit in the ground and started building pits up above the ground out of either bricks, as Daddy and I did in 1951, or out of concrete blocks, as the Huggins family did.

It is worth noting that these backyard barbeques were always the learning ground for each generation of new barbequers. And just as Jackie Hite told of learning at his father's side in his backyard in Leesville, Edna Huggins noted in the material she sent to me that Davol Davis (whom she said always helped her father) and his partner, Jackie Cockfield, were the founders of Big D's BBQ in Hemingway.

It's been a long time coming, but today, the golden age of barbeque, helped by the efforts of all of our people and our ancestors, is here.

THE BARBEQUE CAPITAL OF SOUTH CAROLINA AND THE WORLD

When you talk about barbeque, you are not talking about France or Italy, despite their well-deserved reputations for fine cuisine. No—when you are talking about barbeque, you are talking about the United States.

In the United States, real barbeque is almost overwhelmingly a southern food. As you head north out of the Deep South into say, Virginia, barbeque starts petering out. Kentucky, protected largely by the Ohio River, has managed to maintain a good barbeque tradition, especially in mutton, which was on everyone's menu in the 1920s and '30s. But Kentucky lacks the percentage of barbeque restaurants that even its neighbor Tennessee can claim.

No—barbeque is primarily Southern and primarily in the Deep South, with noticeably fewer real barbeque houses in the border states. Although there are some fine and rightfully famous barbeque houses in Kansas, Missouri and even Illinois, it is in the South that barbeque is a staple of today's diet. But when you think of the South, there are only two states that can truly claim a leading role in this culinary art form: South Carolina and North Carolina. As I have said in other places in this book, I have a fond place in my heart for the Old North State since so many of my ancestors lived there for hundreds of years. North Carolina can claim some fine barbeque houses and a truly long tradition of real artists turning out real barbeque. But when it comes to the center of real barbeque, there is simply no disputing that it is South Carolina.

South Carolina is where barbeque was invented, South Carolina is the only state with the four major sauces and South Carolina leads the nation in barbeque cook-offs and competitions on a per-capita basis, with almost every weekend boasting at least one competition being held somewhere in the state. South Carolina is the state with the most progressive barbeque association, a group of dedicated amateur barbeque enthusiasts whose innovation and leadership is being copied and imitated around the nation. The United States is the world leader in barbeque, the South is the United States' leader and South Carolina is the South's leader. In other words, South Carolina is the world capital of barbeque. There will be many people who will challenge that logical and rational statement, but those challenges fall into the category of "our girls are prettier than yours" and "our football team is better than yours." In other words, it is a fun argument, but not one to be taken seriously.

Once you accept the reality that South Carolina is the true capital of barbeque, another question arises: Where in South Carolina is the epicenter of barbeque? This question is a bit of a challenge, and many people just might give a nod to Williamsburg County, which has numerous good barbeque houses and a centuries-long tradition of wonderful barbeque. But in terms of population, Williamsburg is a small county, and it can't really support an expanding barbeque scene. If we expanded the Williamsburg County area into the Pee Dee area (Williamsburg is actually part of the lowcountry, not the Pee Dee region—but the barbeque in the Pee Dee is remarkably like Williamsburg barbeque), then an unfortunate thing happens. From the upper Pee Dee, which includes towns such as Dillon and Marlboro, all the way to Myrtle Beach, the number of good barbeque restaurants is actually, on a per-capita basis, not very high. In Latta, there is a one-hundred-mile barbeque restaurant (Shuler's), and in Florence, there are a couple of barbeque restaurants that are not quite in the one-hundred-mile category but are still very good. There are several from Scranton to Lake City, as well as various crossroads and out-of-the-way restaurants, including Scott's in Hemingway and McCabe's in Clarendon, both of which are one-hundred-mile barbeques. In other words, in the Pee Dee, there is truly great barbeque to be had at a few places. Plus, there are a large number of places that can satisfy any person if an actual barbeque emergency arises.

That being said, however, the tip of the hat has to go to Lexington County. Lexington County is home to Shealy's Bar-B-Cue in Leesville, and Shealy's is the largest barbeque restaurant in the state. The Shealys began their business as a takeout operation, installing a nice covered pit with drop-down windows at their home. Mr. Shealy sold his barbeque, and Mrs. Shealy sold her homemade cakes. The original takeout building is still standing, having been built so well that it has weathered many years in good condition.

The Shealys' business prospered, and they decided to move on to a sit-down restaurant. It started in 1969 as a small place, and by 1970, they had installed what is likely the very first barbeque buffet in the state. Those emerging barbeque buffets that followed in the Shealys' footsteps conditioned two generations of patrons to line up for barbeque and learn to help themselves. It also gave Mr. Shealy a leg up on the competition, as he was a pioneer. The little one-room 1969 Shealy's building has been added on to so many times that it's hard to keep count. A walk through the building will reveal several large rooms that were obviously added on, while a walk around the outside will show the same.

This remarkably well-preserved building was where the Shealy family of Leesville, the progenitors of the largest barbeque restaurant in the state, served takeout barbeque for years before they opened their restaurant. *Courtesy of Clarissa L. Johnson.*

Opened in 1969, this Shealy's restaurant is the largest barbeque restaurant in the state. Soon after they opened their new restaurant, the Shealys installed a buffet line and quickly had to add on more rooms to handle the crowds. *Courtesy of Clarissa L. Johnson.*

As of 2013, Maurice Bessinger has over fifteen restaurants across the state. *Courtesy of Clarissa L. Johnson.*

Lexington County is also the home of Maurice's Piggie Park, and Maurice's is the largest barbeque serving operation in the state. It may be true that Shealy's is the largest single barbeque restaurant, a fine accolade in itself, but Maurice's empire is composed of fifteen restaurants in six different cities around the state. Plus, Maurice's is a genuine one-hundred-mile barbeque house, as every bit of barbeque that is served in all of its fifteen outlets is pit cooked over real coals made from hickory wood. Indeed, it just may be that Maurice's serves the largest amount of real pit-cooked barbeque in the nation.

Lexington County is also the home of Jackie Hite's Barbeque, the last barbeque restaurant in the state that still cooks whole-hog and places a hog on the buffet line for a genuine pig picking. On Fridays, starting at about 11:00 a.m., the first half of a pig goes up on the counter, and about noon, the second half of the pig is brought out. Nowhere else in the state can you get real pit-cooked whole-hog regularly put out so that you can pick your favorite parts. As you would expect, the ribs and rib meat go first, but the hams, shoulders and belly meat also have their followers. Occasionally, McCabe's in Manning will put out a half pig to be picked, but they don't do it every week the way Jackie Hite does. If you want barbeque the way it was 150 years ago, whole-hog cooked over a dirt-lined pit with real coals made out of hickory and oak and placed out for your picking pleasure, then Jackie Hite's in Lexington County is your only choice.

And speaking of Hite's, the other Hite in the business in Lexington County is Jerry Hite, who is still holding forth on Dunbar Road in West Columbia in

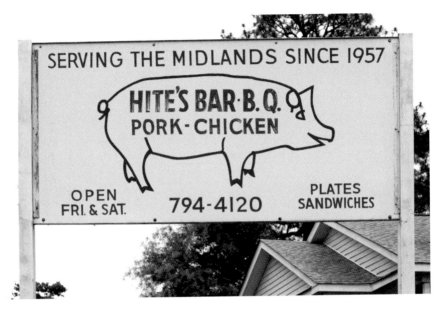

Jerry Hite and his son are still cooking and serving at Jerry's takeout operation that has been in West Columbia since 1957. *Courtesy of Clarissa L. Johnson.*

the same takeout place that was opened back in 1957. Jerry Hite and his son David are still cooking whole-hog along with some butts, and it is genuine one-hundred-mile barbeque. Jerry's skins, and those of his distant cousin Jackie, are simply the best in the state. One of our SCBA certified judges commented that while Jerry's barbeque might be in the one-hundred-mile category, his skins are two-hundred-mile skins. In fact, Jerry Hite's skins are so good that you have to call in at least one day before they are prepared for sale and reserve some if you want to get any.

But Lexington is not just the home of the biggest and the best, there are also other one-hundred-mile barbeque houses to be had in this most barbeque rich of all of South Carolina's counties. Belly's Southern Pride Bar-B-Q to the west of the town of Lexington is a one-hundred-mile house, and its ribs are considered by some to be the best in the state. Belly's is run by Richard and Tom Shealy, who must be some sort of cousins of Tommy Shealy in Leesville. Belly's is always mentioned in any conversation about ribs. This is remarkable when you consider the fact that it occupies the same territory as Maurice's, which is also in the running for best-in-the-state honors in the rib department.

There is also Hudson's Smoke House to the east of the town of Lexington. Robin Hudson gave up a career in the auto business to open a small takeout

barbeque stand. He brought a North Carolina style (his home state) barbeque that soon had patrons lining up outside his little one-window takeout stand. He then added a few picnic tables and covered a small area just outside of his takeout window. The tables were always full, so he eventually added on a large room. He then had to add another very large room and then another—and the line was still out the door. Hudson even has a building in another part of the county just to handle his catering business.

After a few years of ordering from the menu, Robin Hudson finally went to a buffet, where his catfish, chicken and chicken livers vie with his barbeque for top honors. He also serves fresh-cut sweet-potato fries and fresh-cut French fries that have been called one-hundred-mile French fries. His sides of macaroni and cheese, sweet potatoes, broccoli casserole and slaw are big favorites, as is, when you get right down to it, everything on his menu.

Hudson uses a gas-fired flame to ignite his hickory and oak wood that he uses for both a heat source and for smoking. He has learned that one need smoke only about five hours after the barbeque is cooked tender to give it sufficient smoke flavor. His restaurant is a newcomer to the Lexington barbeque scene compared to Maurice's (1954), Jerry Hite's (1957) and Shealy's (1969), but he holds his own and then some.

But back to Maurice's for a minute. Four of Maurice's fifteen restaurants are located in Lexington County—his home restaurant in West Columbia, one to the west of Lexington, one to the south of Lexington just off of I-20 and one in Irmo, just off of I-26—so you are never that far away from that gold standard in traditional German mustard-style barbeque.

There are a passel of other barbeque places in Lexington County that stand ready to handle those people who want to eat it now and can't take the trip to one of the one-hundred-mile houses. Country Kitchen in the southern part of the county has had a loyal following for decades, serving side dishes that people ride miles to get. Located on the Orangeburg side of Lexington County, their hash and barbeque take on the unique flavor of that area. Little Pigs in Ballentine also stems from the Orangeburg tradition, and if one simply has to have that reddish Orangeburg-style hash, then they are ready when you are, except Mondays, when they are closed. They also have some of the best fish dishes around, reminiscent of the old fish camps that also served barbeque and are found more often in the upstate and in North Carolina.

So, South Carolina is the barbeque capital of the nation, and Lexington County is the barbeque capital of South Carolina. Thank goodness Lexington County is situated in the center of the state, easily accessible to all.

Chapter 7

TV, SAUCES AND CONTESTS

In South Carolina, the golden age of barbeque has gone platinum!
As previously mentioned, we are in the best of times for barbeque, with all of the new restaurants coming on the scene, all of the television shows about barbeque and all of the newly formed cooking teams crisscrossing the country and cooking in the hundreds of barbeque cook-offs that have sprung up in the last ten years or so. There has never been so much barbeque to enjoy, and it has never been better. In South Carolina, we are doubly barbeque blessed. All it took was a little planning and a few years of concentrated effort.

In 2004, my friend Dr. Walter Rolandi and I formed the South Carolina Barbeque Association (SCBA). We were coming back from judging an independent barbeque event in Florence. Walter, who was driving and had his eyes still on the road but with a grimace on his face, said, "You know, South Carolina has the best barbeque in the whole nation and the worst judges." We had just finished judging a contest that had seventeen cook teams. Originally, the organizers had gotten just the two of us to judge the event, which meant that we would have to judge too many samples to do a good job. We recruited two more judges and knocked that event out the best we could even though we were understaffed. Walter, having judged a couple of other contests across the state and having had the opportunity to see a few dozen amateur judges work up close, was disturbed by the quality of the amateur judging he was seeing.

Having been a certified wine judge for over twenty years at that point and having judged dozens of large wine contests, as well as a good number

of barbeque contests, I knew the difference between good, well-trained, professional judges and the type that were making the rounds in South Carolina. Given that background, I could only agree with him. Then I said, "I think we can do something about that. Let's start a barbeque association and teach people how to judge."

Over the next several weeks, we exchanged emails with thoughts on the subject, had telephone conversations and went out to eat barbeque at various restaurants to kick around the idea of a barbeque association. What we came up with was a strategy to maintain and promote the diversity of South Carolina's four distinct sauce styles, a plan to help local towns and cities get contests started and a method for producing well-trained, qualified judges with a fair and a well-thought-out judging process. We also had the goal of putting South Carolina on the national barbeque map in its rightful place, which is first place.

This goal of making South Carolina the recognized leader in barbeque was the direct result of having seen a number of shows, mostly on cable television, showing barbeque cook-offs, telling an ersatz form of barbeque history and claims being made to a national audience by people who obviously had no idea of what they were talking about. For instance, the one I found most egregious was an introduction to one program in which the narrator said, "Barbeque can be found all over the nation, but there are only four places where it really matters: Texas, Kansas, Tennessee and North Carolina." The word in that sentence that got me the most upset was "matters."

The problem was evident to anyone who had worked in television and advertising, which I had. That original program had been either sponsored directly or underwritten by some operation in Texas, since slightly over half of that one-hour program was about Texas, with the remaining half touching on Memphis, Kansas City and North Carolina. Unfortunately, the footage from that original program was reworked into a second show that was also shown on the Travel Channel, and it had the exact same lead-in with that remarkably incorrect statement about what places in the nation "matter" when it comes to barbeque. Now this may not seem like such a big deal, but a program that purports to be factual is so much better at spreading a message than a standard commercial that one sees on TV. The impact on the unsuspecting is incalculable. If one takes just the minutes they spent talking about barbeque in Texas and calculating it out in dollars necessary to buy a commercial that long, it would run into the hundreds of thousands of dollars. When you consider that those shows are repeated dozens of times in the first year of their production and for years afterward,

then whoever underwrote that original show got millions of dollars worth of free advertising.

That same show then went on to show a group of judges, with the narrator saying, "Who better than a cowboy to judge barbeque?" They then showed several modern-day California ranchers, all of whom could only be described as "hefty," riding across a dusty field on some poor overburdened horses. It looked to me as if these worthies had been picked by the show's producer with the idea that they must certainly have had the opportunity to sample lots of barbeque in their lives. Who better indeed? Well, maybe some trained judges from a state where there was a real barbeque culture and lots of barbeque served, rather than some state more famous for its tacos.

The television producers then had some catering outfit cook up four different types of roast pork (from the looks of the cooking apparatus that they briefly panned the camera over to, it did not appear to be barbeque) to match the four sauces that they had described in the program: the Kansas style, with a thick, sweet, heavy, brown finishing sauce; a Memphis style that looked virtually the same; some beef that represented Texas; and what appeared to be a reasonably interesting eastern North Carolina-style barbeque that was at least pulled pork basted with a vinegar-and-pepper sauce. These cowboys and cowgirls were then served a remarkably large plate of food, and I do mean large. It was complete with meat, beans and some other unidentifiable piles of vegetables and topped off with two large slices of buttered Texas Toast. They were directed to a long picnic type table and told to dig in. That plate could only have been served to those "judges" to keep a promise that had been made earlier that if they participated in a TV show, they would not only be on national television but they would also be well fed. After polishing off that first mega-meal, they were then served another plate that looked as overloaded as the first. That was only the second of four plates, all piled high, that they were supposed to taste and judge.

The fact that in a real barbeque-judging contest the judges receive only a small portion of each sample they are to taste had eluded the producer of that show. The reason for the small samples is simple. You favor any food you taste when you are hungry. If you are completely satiated, then almost nothing tastes good. So it was no surprise to me that the pork that was tasted last, the one most like real barbeque, the North Carolina style, was voted the least favorite of the four. But since the "cowboys" were actually from California, where real barbeque is a rarity, they wouldn't have known real barbeque even if the taste-off had been conducted properly.

A serious judging by trained barbeque judges shows that only a small amount of barbeque is tasted, one against the other, with decisions being recorded on a numeric scale. Professional judges assess taste, texture, tenderness, aroma, appearance and overall impression. The numbers awarded for each of those categories are then tallied to see which barbeque scores highest. *Courtesy of the author.*

As bad as that show was, the worst part about it was that over the course of the following years, that program has been shown over and over to millions of Americans who have been told that Texas barbeque is the best in the nation, that North Carolina barbeque is the worst and that in all of the nation, only four states have barbeque that really matters. There was, of course, no mention of South Carolina—the state where barbeque was born, the only state in the nation with four types of barbeque sauce and the state with more barbeque cook-offs per capita than any state in America.

The whole show was a dazzling display of the lack of barbeque expertise of northern and Californian television producers and writers.

But as I say, Walter and I set out to help correct all of this misinformation, as well as to help South Carolinians celebrate their best-loved food. In the first seven months of operation, starting in June 2004, the SCBA held three seminars to teach hopeful beginners some of the finer points of judging. The first one was held in Columbia and saw sixty-seven people show up to become judges. The second SCBA seminar was held in Simpsonville, with about sixty-five people attending, and the third was held in Florence, with fifty-one present and accounted for. All of these people, plus others that signed up but who had not yet had a chance to take a seminar, were counted as charter members of the SCBA and given a certificate stating such.

In October 2004, the SCBA also sponsored, along with the South Carolina Department of Agriculture, the first Carolina Q Cup, which was held at the then South Carolina State Farmers Market. The commissioner of agriculture in 2004 was Charlie Sharpe, who was from Aiken County. Sharpe was a farmer in his own right and a big supporter of all things South Carolina and agricultural. He marshaled the support of his staff as well as the South Carolina Pork Board, and the first Carolina Q Cup saw fifty cook teams lined up under what was called the Watermelon Shed, a large open-sided building that covered a couple of acres and was used to sell fresh produce to the public. The event lasted two days, and over that time, about four thousand people showed up to buy a ten-dollar bracelet that would allow them to sample barbeque from any, or all, of the cookers. The effort was advertised as an opportunity for people to come taste all four South Carolina types of barbeque side by side and get all of the barbeque they could eat from different areas around the state, some of which they may never have tasted before. It was to be both fun and educational. It was the first time in South Carolina that the fact that South Carolina was the home to four distinct types of barbeque had ever been widely celebrated and multiple samples of each type were laid out for all to try.

The following year, in 2005, Carolina Q Cup took on an even improved flavor. The fifty teams had been expanded to sixty teams, but the same format for the cookers was followed. Both butts and whole-hog were cooked and judged. Governor Mark Sanford came to the second event with his family, and he was joined by many other notables from around the state. Adjutant General Stan Spears, Superintendent of Education Inez Tenenbaum, Richland County Sheriff Leon Lott, Commissioner of Agriculture Hugh Weathers and various state legislators and senators also came. Plus, WIS-

Governor Mark Sanford was quite at ease in the large crowd at the Carolina Q Cup, where he spotted a number of old friends and supporters. He graciously posed with anyone who wanted a souvenir picture, as he did here with the team from the Richland County Sheriff's Department. The men from the sheriff's department won first place in the First Responders Division of the contest. *Courtesy of the author.*

TV, which had also been a sponsor the opening year, showed up again with a large satellite truck and a couple of TV personalities to do their broadcast from the Watermelon Shed.

The turnout the second year was even larger than the first. Governor Sanford welcomed everyone; Huge Weathers, the new commissioner of agriculture, gave out trophies to the cook teams; and Inez Tenenbaum gave out trophies in the children's division of the cook-off. Adjutant General Spears gave trophies to the First Responders Division of the cook teams. Governor Sanford, it turns out, was no Johnny-come-lately to the barbeque scene. For his first inauguration party, he had junked the idea of the usual formal black-tie ball and in its place held a barbeque for thousands of invitees, rather than a select few hundred who might get crowded into a ballroom. In fact, his inaugural barbeque was held in the same place as the Carolina Q Cup, the Watermelon Shed at the State Farmers Market, with about a dozen different barbequers from all parts of the state setting up and serving several thousand guests.

During the first Carolina Q Cup, the SCBA had been able to muster seventy-five certified judges to handle the event. By the second event, we had

to restrict the number who wanted to help judge because we had more newly trained judges than we needed.

The SCBA has never solicited any town or organization to hold a barbeque cook-off. That might seem a bit odd, considering that helping people put on barbeque contests was one of the original goals of the SCBA. But we have found that those who are interested enough to take the initial step to call us are more apt to follow through with their plans. But once they do call, we give them all the help they need to set up a barbeque cook-off in their town. Given this "let's-get-it-done" philosophy, South Carolina now has more per-capita cook-offs than any other state in the nation. In 2012, the SCBA, just eight years after its founding, helped over thirty-five towns and organizations put on barbeque cook-offs. Generally, these cook-offs were sponsored by charitable organizations such as the Children's Cancer Society of Easley, the Friends of Caroline Hospice in Beaufort, Project Host in Greenville and the Boy Scouts in Sumter. There were chambers of commerce in Mauldin, Lake City and a handful of other towns that held barbeques to help augment their coffers as the recession of 2008 got under way with a vengeance. Save for the rare occasions during which the weather was so poor that the event had to be canceled, all of these events showed a profit of anywhere from $2,000 to $35,000 their first year, with a few doing even better than that. This sort of profitable fun caused group after group to sign up to start their own cook-offs.

The biggest impetus for the growth of barbeque across the nation, however, has to be television, which has had both positive and negative effects on barbeque in America. First is the fact that in 1948, the H.J. Heinz Company introduced a "barbeque sauce" that was heavily flavored with tomato, since Heinz was the nation's largest producer of tomato puree, the base for ketchup. While this sauce was not the very first barbeque sauce produced for sale to the public, the company was so large and covered such a large national market that it was the first one that was truly successful nationwide. This Heinz product did reasonably well on the store shelves, so in 1955, Kraft Foods, another large nationally known company, put the first truly successful commercially available barbeque sauce on the market. It proved to be a bigger seller than the Heinz sauce because it was advertised widely on TV.

I remember those first Kraft bottles—they had a label that showed a redbrick background that was supposed to suggest to the customer the brick barbeque pit that thousands of Americans were beginning to build in their backyards. There was even an *I Love Lucy* episode in the late 1950s that centered around Ricky and Fred building a brick "barbeque" in their

backyard, and since that show was the number-one show on TV at that time, I think that particular episode helped inspire people outside of the South to start calling their backyard grill a "barbeque."

While the marketing power of TV has inserted barbeque sauce into almost every home in America and made "barbeque" a household word, neither Heinz nor Kraft had the first barbeque sauce on the market. It's really hard to say what the first commercially produced sauce was. There were some local sauces that were produced and sold only locally, and references to them can be located in various newspapers across the country. They all seem to have been on the market for a short time and then disappeared.

In Georgia, there was a sauce advertised in the newspaper as far back as 1909 put out by the Georgia Barbecue Sauce Company, but it disappeared soon after that. In its ad, the company suggested that the sauce was good for everything from Brunswick stew to oysters. The ad, which was similar to the label, does show an old African American man preparing barbeque over a pit that has been dug in the ground, which means that the makers of that sauce knew what real barbeque was.

One that did last was Maull's Barbeque Sauce, put on the market in St. Louis, Missouri, in 1926. The Maull Company had been offering sauces and condiments beginning in 1920, so in just six years, they saw a need for a barbeque sauce. That sauce can still be found on the market today (I've seen it once in South Carolina). Interestingly enough, most of the barbeque sauces I've uncovered (including the Maull's sauce) in old newspapers have been in northern and western newspapers. My supposition is that southerners knew how to make their own sauce and didn't need a commercially produced sauce.

In Macon, Georgia, Mangham Griffin created a sauce that he called Mrs. Griffin's Barbecue Sauce, thinking that people would be more inclined to buy a sauce that was made by a woman. It has since been slightly re-labeled and is called Mrs. Griffin's Original Barbecue Sauce. That sauce, one of the oldest in the nation, is of special interest to South Carolinians because it is a hybrid between a mustard sauce and a tomato sauce. You see, the Griffins had South Carolina relatives, and when those relatives would come to Macon for family visits, they wanted a mustard sauce to go with the barbeque. However, the Georgians leaned toward a tomato-based sauce. But Mangham Griffin developed a sauce that pleased both sides of the family by mixing mustard and tomato together. That blend is the original Mrs. Griffin's sauce, and to this day, its reddish-yellow color gives away its mustard heritage. That sauce has been sold throughout Georgia and surrounding

Top: Mrs. Griffin's sauce has been on the market longer than any other except Maull's, and it still continues to slowly expand its market. *Courtesy of Clarissa L. Johnson.*

Left: Scott's vinegar-and-pepper sauce out of Goldsboro, North Carolina, was put on the market in 1946, although its formula predates that by decades. It is still on the market today, and some of the SCBA judges consider it the touchstone of bottled vinegar-and-pepper sauces. *Courtesy of Clarissa L. Johnson.*

areas since 1935, thirteen years before the Heinz effort and a full twenty years before the more successful Kraft entry into the market.

The Scott family of Goldsboro, North Carolina, started making a vinegar-and-pepper sauce for their barbeque takeout eatery way back in 1917, but they didn't bottle it for sale until 1946, two years before the Heinz effort and nine years before Kraft's first sauce. It is still on the market today. As you would expect for something that has stood the test of time, it's quite good.

While it is true that Heinz had a successful barbeque sauce before Kraft put its sauce on the market, the Kraft sauce was the first nationwide barbeque sauce that was truly successful. That success can be seen by the fact that Kraft now dominates that nationwide sauce market, while Heinz dropped its effort to concentrate on the larger market for ketchup. Kraft's first effort was actually based on its production of vegetable oil as opposed to the tomato puree base it uses today. The company's first bottle came with a package of spices that you had to mix in with the oil to get the final sauce. It was similar to today's Italian salad dressing. It wasn't long—about a year—before Kraft simply mixed the spices into the oil and put that finished product on the market as a ready-made barbeque sauce.

The Heinz sauce was, as mentioned, rooted in the company's tomato puree products, while Kraft's came out of its oil production. Obviously, there are different approaches to making a barbeque sauce. Regardless of the starting point, there are generally considered to be four types of barbeque across the country, and by and large, they are broken down by the type of sauce used as a finishing sauce. As previously mentioned, there are actually two types of sauce: a basting sauce and a finishing sauce. All real cookers of barbeque know the difference, but when it comes to the mind of an average backyard griller or the average customer in a barbeque house, it is the finishing sauce that determines what kind of barbeque they have.

The four major sauces, in order of historical emergence, are vinegar-and-pepper, mustard, light tomato and heavy tomato. And while there is always disagreement on the varieties of preparation, such as whether one should use a dry rub or a wet rub and various other culinary arguments, almost all of the many sauces used in America will generally fall into one of those four basic groups.

The "original" barbeque sauce, dating back hundreds of years, is vinegar-and-pepper, the first and simplest of the four. It is found on the coastal plains of both North and South Carolina and, to a slight degree, in Virginia and Georgia.

The second (in order of historic evolution) of the four sauces is the one that is distinct to South Carolina and the one that people most often think of

as South Carolina style: mustard sauce. That sauce is the product of the large German heritage found in South Carolina. The first German settlements in South Carolina were located in present-day Dorchester County. Successive waves of settlers moved on up the rivers to the counties of Orangeburg, Lexington and Newberry and the northwestern part of Richland County.

It's interesting to me that the frequent use of mustard is not universal in Germany and that the different settlers from different parts of Germany do not use it in like degree. I remember one evening when I was attending a real-estate seminar, and there were eight of us sitting around a large round table. One of the people at our table was an import from up north who all of us were suffering through. Having retired to the South from the glorious state of New Jersey, he held everything southern in obvious disdain. When the subject of barbeque came up, he sneered at the mere mention of the word. Flexing his intellectual muscle, he loudly asserted out of the side of his mouth in that charming way that lower-class northerners affect, "South Carolinians dan't know anything about barbecue—you South Carolinians use mustard on your barbecue." Having somebody from New Jersey telling South Carolinians they don't know anything about barbeque managed to get the attention of all who were seated there, and everyone turned to stare. I spoke up, as politely as I could under the circumstances, saying that mustard was a product of our German heritage. He then snorted, "Germans don't use mustard. I know. My granddaddy was German." When I then pointed out that I had, just that week, bought a jar of Inglehoffer German mustard at the local Piggly Wiggly, he gave me a hard, sour look and went on to another subject, about which he didn't seem to know very much either. The point is that he descended from some Germans who did not use mustard at all. This was so firmly fixed in his mind that he thought no Germans used it. Of course, the ones that came into New Jersey apparently didn't, and the ones that came into South Carolina did. But he had no inkling of that.

The third type of sauce found in South Carolina, in terms of the evolution of sauces, is light tomato sauce. This sauce was little more than a vinegar-and-pepper sauce with tomato ketchup added. This occurred after tomato ketchup became a readily available condiment around 1900. Ketchup, in all of its various spellings, has been around for hundreds of years, and the word seems to have been used sort of like the word "curry" today; that is, a mixture of various sorts of sauce. In fact, Harriott Pinckney Horry, in her 1770 South Carolina cookbook, writes of a walnut ketchup, and there are lots of old English recipes with ketchup made from kidney beans, mushrooms and even fish and clams—but no tomatoes. Tomato ketchup

as we know it today, a mixture of tomato sauce, vinegar, sugar and spices, has been available on the market since only about 1830 as a commercial preparation. It wasn't until about 1890 that it gained a good foothold in large cities, and it wasn't until about 1920 that it became nationally popular, due primarily to modern transportation and food distribution.

The German immigrants from up north who came to North Carolina didn't have a meat sauce that they had adapted to barbeque, as barbeque was not a food much found north of Virginia. What they did when they arrived in North Carolina was take the vinegar-and-pepper sauce that was already in use in eastern North Carolina and simply add ketchup to it. This light tomato sauce, a vinegar-and-pepper sauce with a bit of ketchup, was already in use in other areas of both North and South Carolina, so they were not its inventor, but they were some of the first regular practitioners of using that light, slightly sweet sauce, especially as a commercial sauce in restaurants. That style of sauce is now most famous in North Carolina in the Piedmont region, of which Lexington, North Carolina, is the generally acknowledged barbeque center. A light red vinegar-and-pepper sauce is also popular in the upper middle part of South Carolina and in the Pee Dee region.

The fourth sauce found in South Carolina and, for that matter, the rest of the nation, is a sweet, heavy tomato sauce. This sauce has evolved only recently, in the last seventy or so years. Despite its being the latest entry into the barbeque-sauce fold, it has spread rapidly over the majority of the nation due to modern transportation over our new interstate highways, modern marketing techniques, television advertising and the insatiable sweet tooth of the modern American. This finishing sauce, popularized by Kraft and its newer cousin, KC Masterpiece, along with its many imitators, is the type of sauce that most Americans think of as barbeque sauce.

In Bob Garner's excellent book on North Carolina barbeque, *North Carolina Barbecue: Flavored by Time* (John T. Blair, 1996), he notes that North Carolina has only two indigenous sauces: eastern North Carolina vinegar-and-pepper and the Piedmont sauce, which is a vinegar-and-pepper sauce sweetened with a few spices and a little ketchup. His use of the word "indigenous" tells me that he feels those two sauces arose in North Carolina. He does acknowledge the third type that exists, the thick, sweet sauce found in the Smokey Mountain side of the state, but he doesn't seem to claim it for North Carolina. And while it certainly wasn't created there, it is used there in the western part of the state. He made note of it as that thick commercial-type sauce that is a product of the twentieth century.

As you might imagine, South Carolina has, in this modern platinum age, filled the grocery shelves with a large variety of sauces. This bounty is rather recent, with most of them being added since 1990. South Carolinians have a very large variety of sauces to choose from if they want to experiment with and enjoy a distinctive finishing sauce. The only catch is that they have to go from store to store to see what is being offered, because while every large grocery chain will stock the ubiquitous Kraft and KC Masterpiece and Sweet Baby Ray's with their cheaper ingredients, they really do differ in the locally produced sauces they carry.

Following are some (but certainly not all) of the sauces that you can find in your local stores that have an origin in South Carolina. They are listed in alphabetical order: Bessinger's, Big Ed's Heirloom BBQ Sauce, Big T's, Blackjack Barbecue Sauce, Boss Hog's, Carolina Gold, Chuckey's, Coleman's C.H.S., Dad's Recipe, Hudson's Smokehouse, KK's Kurly Tails, Lube Man Mark, Mama Sue's, Maurice's, Mic-B's, Old Plantation, Pee Dee Swamp Sauce, Piggly-Wiggly Bar-B-Que Sauces, Po Boy's, Prosser's, Q2U, Sassy Sauce, Shealy's, Smokin' Cole's, Southern Home, Sticky Fingers, Tail-Gater Hater, Uncle Albert's, Uncle Pete's and Wadmalaw Island Barbeque Sauce.

Some of these South Carolina–born sauces come in only one style, but most of them come in various types such as a mustard sauce, a light tomato sauce or a vinegar-and-pepper sauce. Most have a sweeter version, sweetened with honey or molasses. A few even offer the thick, sweet, tomato puree style of a Kansas City–type sauce. For instance, the creators of Q2U told me they put one on the market just to satisfy the demand of all the northerners who have settled around Tega Cay in York County, south of Charlotte. Even Shealy's, which has a German heritage as long as anybody's, has now added a thick, sweet sauce that it sells in stores alongside its vinegar-and-pepper sauce and its signature mustard sauce.

Note that the Southern Home sauce, both its mustard style and vinegar-and-pepper style, is a store brand of the Bi-Lo chain, which was started in Greenville. And even though Bi-Lo is now owned by a European company, its ties with South Carolina are old and strong, and South Carolinians still think of it as a South Carolina store. This store-brand sauce is quite good and inexpensive, and its mustard sauce won a Silver Medal in the yearly SCBA sauce contest.

And speaking of Bi-Lo—that reminds me that the larger grocery-store chains are not the best place to find your locally produced South Carolina sauces. As the national brands expand their lines to include variations of flavors, they have crowded the South Carolina brands off the shelves. It

works like this: if the chain wants to carry Kraft (and they do), then they have to stock all of the variations that Kraft offers, or the company will pull their products. So in years gone by, there might have been only one type of a national-brand sauce on the shelves, but now they have generally expanded into three or more styles carrying the same brand. As those brands expand, the stores have less and less space for local products.

The best place to find South Carolina sauces (and that is what you want to do since they almost invariably have better ingredients and a more pleasing taste) is a locally owned grocery store. Thank goodness Piggly Wiggly stores are locally owned (although they are also connected to a national chain). I once found eleven different South Carolina sauces in one Piggly Wiggly. By different, I mean different brands; there were actually eighteen different flavor combinations among those eleven brands. I found four more different South Carolina sauces in another Piggly Wiggly that was only a few miles away from the first store I visited. Other locally owned stores that carry a treasure trove of local sauce brands include IGA, Reid's, Red & White and Ingle's, as well as lots of locally owned convenience stores.

Having mentioned all those sauces and the contests that the SCBA conducts, this is the perfect time to go into that event, as it can give you some guidance in tasting sauces. Each year, the South Carolina Barbeque Association assembles anywhere from sixty to eighty certified barbeque judges in Columbia and has them judge a variety of barbeque sauces. These sauces come from a variety of sources, including locally produced sauces or nationally produced sauces. The only restriction is that they be properly bottled under FDA standards and available for purchase by the general public. These judgings are conducted blind; that is, each judge is given a small amount of sauce in a two-ounce cup along with some tiny spoons and asked to rate the sauce identifying them only by the number that is printed on the side of the cup. The judges never see the name of the sauce until the contest is over.

The sauces are arranged by type. For instance, we have learned that one should taste mustard-based sauces before tomato-based sauces in order to get a better judging result. Vinegar-and-pepper sauces should be tasted last. Hot pepper sauces are generally given an overall low score on average since so many people do not like highly spiced sauces. Those sauces are no longer tested with regular sauces, as their scores will not be comparable. However, the SCBA does hold a hot-and-spicy sauce tasting so that spicy sauces can be tested side by side in a blind tasting.

The SCBA rates the sauces and grants medals (gold, silver and bronze) rather than places. That way, it is not a question of whether the judge likes

it but whether the sauce is well made, balanced, pleasing and so forth. This is the way professionals judge wine, and this is the way professionals should judge barbeque sauces. In the four years the SCBA has been conducting its contests, the winners are as follows:

GOLD MEDAL WINNERS: Carolina Gold Classic, Hudson's Smoke House (mustard), Maurice's Southern Gold, Piggly Wiggly Golden (mustard), Po Boy's, Shealy's (mustard) and Smokin' Coles.

SILVER MEDAL WINNERS: Bi-Lo Southern Home (mustard), Pee Dee River Swamp Sauce, Wadmalaw Island (mustard) and Q2U Original.

BRONZE MEDAL WINNERS: Bessinger's (mustard), Hudson's Smokehouse (pepper-and-vinegar), Lube Man Mark, Q2U Thick & Sweet and Wadmalaw Island (pepper-and-vinegar).

The SCBA also tested numerous national brands, but these are the South Carolina sauces that did best. Winning any medal is quite an accomplishment when you consider the strong national competition.

South Carolina's signature sauce, mustard, is finally working its way out of the state. In various national magazines, that sauce is mentioned favorably. In one recent *Southern Living* article, I read a Texas chef confess that mustard sauce was his "new favorite." Native Georgian Alton Brown, a celebrity chef on the Food Channel, did a show on how he does his own backyard barbeque when he wants some for himself. And while he said that he did not believe in sauces, per se, he said that when he did use one, it was a "South Carolina–style sauce." As he said that, he held up a homemade sauce that was obviously quite yellow. In fact, he went on to say that one could make a good simple barbeque basting sauce simply by saving the juice from a jar of pickles and adding yellow mustard to it. I tried that, but in truth, I found it a bit too one-dimensional.

I once saw a show on the Travel Channel in which they talked about real barbeque coming to Vermont. They showed a local restaurant that was set in an old wooden building in some small town. They filmed the smoke coming out of a chimney and commented that the barbeque was being prepared on a genuine smoker. The narrator then said, with a certain amount of amazement in his voice, that the sauce being used was a mustard-based sauce. I turned to my sweet wife and said, "That guy has to be from South Carolina." Then the narrator went on to say that the restaurant owner, who

always had a line of people waiting outside to get in when the doors opened at noon, was a South Carolinian who had married a Vermont girl who had come to South Carolina to go to college. So, even in the back woods of Vermont, civilization is making some headway.

A few years back, a show on the Food Channel was doing a program on the Jack Daniel's Cook-off in Tennessee. The first-place winner was a cook team of four women from the state of Washington, of all places. The sauce they used was such a bright yellow that it looked as if it were nothing more than Kraft yellow mustard smeared on the pig, although I'm sure it was more complicated in the making than its color suggested. The marvelous thing about that is that the judges for the Jack Daniel's event were professional enough to be able to judge a barbeque that was finished with what had to be for them a non-traditional type of finishing sauce.

Budweiser put a new series of sauces on the market, including a mustard sauce, but it is not the only one. Even Kraft has a "honey mustard" sauce in its present lineup. Plus, I spotted a mustard sauce from Florida, Rumboggies Mild Bar B Que Sauce, bottled in Jacksonville, which was being sold in South Carolina. The Rumboggies bottle proudly displayed a blue ribbon on its label with the words, "Award Winning, American Royal International Barbeque Sauce Contest, Kansas City," so it obviously did well in that contest. Carolina Treat is a mustard sauce that is sold throughout North Carolina, South Carolina and other states even though it is actually made in North Carolina. Big Bob Gibson, who is an Alabamian, does a nationwide sauce business and includes a mustard sauce in his lineup. Even American Stockyard Sauces out of Kansas City carries a mustard sauce, along with a note on its label saying that mustard sauce is attributed to South Carolina's German heritage. So, even outside of the Palmetto State, mustard sauces are making steady inroads.

The Internet has been another big promoter of mustard sauces. One can literally find one hundred different recipes for a mustard sauce by simply typing "mustard BBQ sauce recipe" in a search engine. This means that thousands of lucky Americans outside of South Carolina have had enough interest in a new culinary adventure, like that chef in Texas, to try something different. If all they have ever had was that thick, sweet sauces that Kansas City and Memphis have made famous, then they are truly ready for a new adventure in flavor.

Of course, there is a real reason for the use of mustard sauce on barbeque: mustard enhances pork. Pork is a naturally sweet meat, and the bit of bite that mustard imparts compliments it perfectly. That is why hot dogs, which were traditionally pork, were always served with mustard rather than ketchup.

In fact, in Chicago, which claims the invention of the hot dog at the 1893 Chicago Exposition (the St. Louis World's Fair of 1903 also claims it, but in truth, hot dogs have been around since the mid-1500s in Germany), the hot-dog vendors there disdain any ketchup at all on their Chicago-style hot dog and they say so as a matter of course while heaping on the mustard.

The lowcountry of South Carolina, not counting Charleston and its surrounding area, has traditionally had a vinegar-and-pepper sauce. That sauce goes up the coast through the Pee Dee into North Carolina. Most people, however, find a straight vinegar-and-pepper sauce a bit too demanding for their taste, and in most of that area, you will find a variation of that sauce in the form of a light tomato sauce with a few additional spices added. In restaurants along the coast from Georgia to Virginia, the light tomato sauce reigns supreme. It is also found in South Carolina's upstate, but restaurants from Pickens County to the Pee Dee are now offering a mustard-type sauce as well.

Another way the SCBA has changed the face of barbeque in South Carolina is on the tables of the restaurants. There are a few restaurants that serve only their own sauce, but most restaurants now have several sauces on their tables so that the customers can alter the flavor profile of their barbeque. This recent change is the direct result of the SCBA educating the public to the fact that South Carolina is the home of four distinct sauces. Before 2004, restaurant owners, and even most of the people in South Carolina, simply were not cognizant of the fact that there was so much diversity in finishing sauces. Now they are mindful of it, and the restaurants and customers are trying new flavor combinations.

Another SCBA-wrought change in barbeque in South Carolina is in the number of teams that are now cooking in contests around the state. In 2004, there was a list of cook teams that the South Carolina Department of Agriculture maintained, but it was replete with duplications and contained a large number of teams that were defunct.

In 2004, there were about 125 cook teams that would compete in several events, but in truth, there were not that many events in which they could cook prior to the advent of the SCBA. Some of those events around the state were KCBS events or independent events with local celebrities handling the judging. While the KCBS events had judges trained after a fashion, the problem with the local independent events was in their rounding up local judges to handle the affair. They generally got the local sheriff, the mayor's wife, the town drunk and whomever else they could find and turned them loose on the teams.

After the SCBA came on the scene, the number of local events grew by leaps and bounds. As more and more events came about, the number of teams that would cook in three or more events climbed to over 200, with as many as 250 teams that might cook locally at least once each year. Plus, a good number of SCBA members have left their judging behind and started their own teams. The upshot of all of this is not only a larger number of events but also more and more cookers.

If you ask the team captains how barbeque has changed over the last ten years, they will all tell you that the competition has caused barbeque to get better at these many cook-offs. The professional judging has caused them to sharpen their skills, and now South Carolina teams do very well against teams from around the country. Plus, the multiple cash prizes that are now being offered have tempted more and more cook teams to join the barbeque fray.

Another problem with getting only local judges to handle an event was that they carried their local bias into the judging. This is only natural. The local judges liked the barbeque they had grown up with, and it was reflected in the winners of the local events. That meant that if a cook team came to the event from out of that area, it stood little chance of winning, so it didn't bother to come. Now, with the SCBA providing judges from all over the state and training judges to ignore any personal bias, a team from the upstate is just as apt to win in the lowcountry as it is at home. This was proven at the very first Carolina Q Cup back in 2004 when a team from Pickens County won the gold medal for butts and a team from Georgetown County won the gold medal for whole-hog. That pattern has held throughout the state ever since in any event the SCBA has judged.

The SCBA brought another innovation to the state that is now catching on nationwide. Back in 2008, the SCBA inaugurated a system for recognizing the state's top barbeque teams with what it called the Master Barbeque Award. At each event the SCBA judged, points were given to the top ten winning teams. Most events can afford to pay only three or four places, but the SCBA gave points to the top ten winners even if they did not place "in the money," as we say on the barbeque circuit. The top winner of each event got twenty points, the second-place winner got eighteen points, the third place winner got sixteen points and so on down to the tenth-place winner, who got two points. This point system is easy to understand, and it was roughly based on the well-understood system that NASCAR uses to determine its yearly leader. For 2013, the SCBA reverted to its original scoring form, which used the actual score each team received in any contest and took the top twelve scores that a team amassed to determine the leader.

So far, the Georgia Barbecue Association and the Florida Barbecue Association have adopted a similar system, and others are in the process of doing so. The overriding reason for this is easy to see. The birth in South Carolina of this yearlong system helped correct a remarkable problem that existed in naming a state's best barbeque team.

For over twenty years, a service club in the lowcountry ran a yearly contest that was rather well attended but drew primarily from the surrounding area. At one point in the past, someone had gotten the South Carolina legislature to agree that the winner of this event could call himself the "South Carolina State Champion." The problem with that was the "blind-hog syndrome"; that is, as the old saying goes, even a blind hog can root up a nut sometimes.

On the barbeque circuit, it is general knowledge that anyone can win a single contest, so given that, there was not much prestige in being the South Carolina State Champion. But in South Carolina, it was even worse than that. On several occasions, out-of-state cooks, notably Big Bob Gibson from Alabama and Myron Mixon from Georgia, were the winners of that contest. That meant that for several years, a Georgian or an Alabamian was the South Carolina State Champion.

The other problem with that event was that it used judges with little or no training. At one event I judged, they asked all the people who had ever judged any event (KCBS, MBN, SCBA and so forth) to step to one side of the room, and all those who had never judged an event to move to the other side. The division was about half and half. They then talked with the "never haves" for about an hour, mostly explaining their point system. To say the least, the judging at that contest was not very well done. Another problem they had was that they used a Memphis approach to judging; that is, both blind and on-site judging. As we have long since realized, on-site judging is a very poor way to judge, with the judge knowing just who he is rating and some local judges not being able to resist giving higher scores to their friends.

However, after a couple of decades, that event began to lose the interest of most of South Carolina's cookers, and they stopped holding it. This was the opportunity the SCBA had been waiting for in order to create a more meaningful state barbeque champion. The South Carolina Legislature, seeing the wisdom of naming a statewide champion only after he had participated in numerous statewide events over a whole year, designated the SCBA as the group that would name the South Carolina Championship Barbeque Team. Now, a team does not get so-named by winning only one event. The South Carolina Champion has to participate in multiple events from one end of the state to the other, and he must face a variety of

well-trained judges. The South Carolina Championship contest lasts from January 1 to December 31 each year and it is conducted throughout the state in nearly thirty-five different towns. This is a far cry from the traditional winner of only one contest claiming to be the state champion. It also puts a stop to a team coming into the state, winning that one event, and saying they are the South Carolina state champs.

To be the South Carolina State Champion, the cooks in South Carolina do not have to always win first place. They could win a few first places, some seconds or thirds or not even place at all in some contests. But at the end of the year, the points amassed by any one team will determine who the best barbeque team in the state is.

In the past, when one team might sneak by some not-very-well-trained judges to win one event, the other cook teams in the state did not give the title of South Carolina State Champion a great deal of respect. In fact, snide remarks were often directed toward those teams. But now, participants in a variety of events all across South Carolina, seeing how difficult it is to place at the top of the order numerous times, give the new SCBA-designated title its well-deserved respect.

This improved system for choosing a state champion is being implemented and discussed all across the nation because it is obviously a better way to name the top teams. Its adoption in a few other states and its consideration for implementation in several others is just another way that South Carolina is leading the nation in barbeque.

As we have learned in previous chapters, barbeque has had a long evolution, from its invention by the Spanish colonists and the Native Americans to its present-day availability seven days a week. It has progressed from a food eaten only on special occasions to a food eaten a couple of times a month to a food that has a daily presence in our lives. It has been a great advancement even if most parts of the country still don't get it right or enjoy it at its best. We do have that advantage here in South Carolina, and that is, to paraphrase a previously mentioned TV show, what "matters."

The latest development in this long and much-appreciated evolution is the mobile barbeque truck.

Mobile food trucks are not new by a long shot. In northern cities, thousands of them over many decades have pulled up into parking lots of factories and served the workers who lined up for gyros, sandwiches, hot dogs and other standard fare. But a barbeque truck that dishes out real barbeque is a new phenomenon, or I should say, it's a new phenomenon in other parts of the country.

Trophies lined up in the South Carolina State House to be presented to the South Carolina State Champion barbeque teams. *Courtesy of the author.*

You see, barbeque trucks were invented here in South Carolina way back in the late 1950s. Sox's Bar-B-Q restaurant, which was located on Harden Street in the Five Points area of Columbia, cooked real barbeque in a pit behind the restaurant and carried it around for sale to catered events and other locations. As you might expect in a state where various artists do barbeque right, there is always some sort of innovation.

However, as more and more sit-down restaurants opened in the 1950s and '60s, that truck was discontinued, and its resurrection was not seen again until the late 1990s and early 2000s. Indeed, when it did appear again, it was such an eye-opener that many of them have been written about in local newspapers and talked about on one food blog after another. Even the *Smithsonian* magazine, a product of the Smithsonian Museum in Washington, D.C., published an article on food trucks around the nation and listed what it thought were the top twenty such operations. One of those top twenty was Bone-In Barbecue, a truck in Columbia, South Carolina. It must be admitted that the good people at the Smithsonian are not the world's best experts on barbeque, however. They talk of barbeque and also

Barbeque trucks may be new on the scene to some, but back in the 1950s, Sox's Bar-B-Q outfitted a barbeque truck and moved it around from event to event. *Courtesy of the author.*

Barbeque trucks have been reappearing across the nation, mostly in areas outside of the South, where real barbeque isn't as readily available. One of those successful new trucks is Bone-In, which operates out of Lexington County. Bone-In was named one of the top twenty barbeque trucks in America by *Smithsonian* magazine. *Courtesy of the author.*

show pictures of trucks in such places as California with pork in pita wraps along with lettuce and tomato among other noticeable lapses. Nevertheless, real barbeque trucks are rolling across the South, and it is likely that you'll see one at various outdoor events.

It's interesting to note that barbeque trucks appear to be more popular in California (and the West Coast in general) than any other part of the nation. This is probably because the taco truck is a longstanding institution in that area, and it was a natural thing to start serving up something else everyone wants in addition to tacos. An Internet search finds tons of barbeque trucks out West, but not so many in the South. But then again, in the South, we have lots of real barbeque nearby. Now we can have public outdoor picnics with real barbeque without someone having to dig a hole in the ground and stay up all night! Indeed, South Carolina barbeque has progressed from its initial invention into a true golden age. In fact, in South Carolina, the golden age of barbeque has gone platinum!

CHARTER MEMBERS OF THE SOUTH CAROLINA BARBEQUE ASSOCIATION

The South Carolina Barbeque Association (SCBA) was incorporated in 2004. Everyone who came to the first three seminars held during that first year was counted as a "Charter Member" of the SCBA. Most of the people named below have stayed with the SCBA, learned how to become the best barbeque judges in the nation and have enjoyed a great hobby while improving the prestige of South Carolina barbeque. These approximately 250 people are, of course, only those who signed up the first year, from July 2004 to July 2005. Since then, more than 700 more people, mostly South Carolinians but some from other states as well, have gone through the judges' seminar and then gone on to get their certifications. Things change, of course. Some people have moved away, some have passed away and some move on to other hobbies and different lives, but for the most part, SCBA judges have continued to be active. At any given time, South Carolina boasts over 600 certified barbeque judges who are willing to use their newfound expertise to advance the happy culinary culture of barbeque in South Carolina, the unrecognized national capital of barbeque.

Charter Members of the South Carolina Barbeque Association:

Mike and Vicky Adams—Hopkins, SC
David Alewine—Anderson, SC
David S. Anderson—Lexington, SC
Kent and June Anderson—Anderson, SC
Barney R. Atkinson—Eutawville, SC

David Bagwell Jr.—Rembert, SC
Brent Bailey—Greenwood, SC
Don Bailey—Fountain Inn, SC
Bess Baldwin—Pawleys Island, SC
Doc Baldwin—Pawleys Island, SC
Bill Barksdale—Columbia, SC
Eddie Baughman—Blythewood, SC
Steve Baxley—Irmo, SC
Barry Bessinger—North Charleston, SC
David Bessinger—Charleston, SC
Susan Bissell—Columbia, SC
Charlie W. Black—Hollywood, SC
Jerry Bolton—Irmo, SC
Gerry Bonnette—West Columbia, SC
Pat Bowen—Charleston, SC
Alton Boyd Jr.—Kingstree, SC
Daniel J. Boyer—Taylors, SC
Hiram Brashier—Gray Court, SC
Greg Brasington—Lancaster, SC
Robert Brescia—Seneca, SC
Walter E. Brooker Jr.—Denmark, SC
Simms Brooks—Los Angeles, CA
Bob and Gary Brown—Folly Beach, SC
Everett B. Brown Jr.—Murrells Inlet, SC
Thomas H. "Tom" Brown—Lexington, SC
Jay Bultz—Myrtle Beach, SC
Marcus Bultz—Myrtle Beach, SC
Donna T. Bundrick—Lexington, SC
Ricky Burrows—Kingstree, SC
Robert S. Burrows—Goose Creek, SC
Thomas M. Butler—Summerville, SC
Robert T. Byrd—Cayce, SC
Rodney Cannon—Andrews, SC
Suzanne Carruthers—Columbia, SC
Sunset Carson—Hilton Head, SC
Charles D. "Donnie" Carter—Florence, SC
Jim Carter—Columbia, SC
Tom Carter—Anderson, SC
Diego F. Carvajal—Mount Pleasant, SC
Ronald A. Chadwick Jr.—Moore, SC
Beth Chaffin—West Columbia, SC

Jim Chaffin—West Columbia, SC
Brent Chitwood—Ballentine, SC
Mary Christian—Eutawville, SC
Mark and Renee Cieslikowski—Lake Wylie, SC
Phil Clark—Irmo, SC
B.K. "Barney" Clegg—Hilton Head, SC
Gene Clifton—Darlington, SC
Ken Coker—Mount Pleasant, SC
Brett Coleman—Asheville, NC
Frank and Nancy Collins—Greenville, SC
Thorne Compton—Columbia, SC
John Cooper—Greenville, SC
Russell W. Cornette—Summerville, SC
Tom Corwin—Columbia, SC
Richard and Becky Cothran—York, SC
Tommy Cotton—Lexington, SC
T.W. Cotton—Orange Park, FL
Phil Cox—Lancaster, SC
Billy Creech—Charleston, SC
Jeff Degood—West Columbia, SC
Charles Dickens—Huger, SC
Tim Driggers—Lexington, SC
John "Jack" C. Dunlap, MD—Columbia, SC
Aaron Dupree—Columbia, SC
William T. "Bill" Eason—Marshville, NC
Mike Edgar—Aiken, SC
Walter Edgar—Columbia, SC
Candy Elkins—Charlotte, NC
David A. Elliott—Hemingway, SC
Cheriee Esteve—Greenville, SC
Mitchell Fairfield—Columbia, SC
Jerry and Diann Faulkner—Belvedere, SC
Curtis Fields—Irmo, SC
Carrie A. Fisher—Orangeburg, SC
Harry W. Floyd—Kingstree, SC
Carl Fortson—Seneca, SC
Mitch Foster—Chester, SC
Malcolm Fowler—Laurens, SC
Mark Fulghum—Moncks Corner, SC
Robert F. Fuller—Columbia, SC
Al Fulmer—Lexington, SC

Tony Gentile—North Charleston, SC
Lindsay Gibson—Chapel Hill, NC
Greg Gillaim—Taylors, SC
Greg and Diane Gladney—Columbia, SC
Tom Glenn—Greenwood, SC
Craig Goldwyn—Brookfield, IL
Bryan Goodyear—Columbia, SC
George Goodyear III—Charlotte, NC
Raymond Griffin Jr.—Lancaster, SC
Tom Griggs—Murrells Inlet, SC
William D. Gwinn—Inman, SC
Mark Hamelink—Effingham, SC
Wayne Hammond—Simpsonville, SC
Allen Handy—Salters, SC
Tim Handy—Summerville, SC
Joe Harden—Hilton Head, SC
Fred Harmon—Sumter, SC
James "Jim" Harmon—Summerville, SC
Rex and Cheryl Harrelson—Kingstree, SC
John and Carolyn Harris—Fair Play, SC
John M. and Flora P. Hart—Charleston, SC
Mike and Terri Havice—West Union, SC
James "Jim" Hayes—West Columbia, SC
Roger Heaton—Orangeburg, SC
Larry B. Herron—Chester, SC
Patrick Heslep—Cope, SC
Jerry Hicks—Mount Pleasant, SC
Lake High Jr.—Columbia SC
Lake High III—Columbia, SC
Doug Hipp—Prosperity, SC
Bill Hobbs—Lexington, SC
Bruce F. Hoffmann—Charleston, SC
Horace Holmes—Conley, GA
Ross Horton—Columbia, SC
Margie Howard—Travelers Rest, SC
Garland and Rebecca Hudgins—Columbia, SC
Phil Hughes—Lexington, SC
Danny Hyslop—Rock Hill, SC
Bobby E. James—Georgetown, SC
Michael R. Jeffcoat—Lexington, SC
Steve Jennings—Fountain Inn, SC

Andrew Jobe—Spartanburg, SC
Michael Johnson—Lexington, SC
Riley Johnson—Pomaria, SC
Stephanie Johnson—West Columbia, SC
Dave Jones—Greer, SC
Terry Jones—Myrtle Beach, SC
Tom Jones—White Oak, SC
Suzette Jordan—Greenville, SC
Zeke Jordan—Hilton Head, SC
J.W. and Pansy Joye—Ridgeway, SC
Jeff Karnes—Summerville, SC
Billy Kemp—Bamberg, SC
Matt Kemp—Breckenridge, CO
Robert L. Kennedy—Seneca, SC
George Kennerly—Orangeburg, SC
Bruce King—Florence, SC
Joe Koch—Lexington, SC
Michael E. Kozlarek—Columbia, SC
Richard Kuppens—West Columbia, SC
Ken Lake—Silverstreet, SC
Hal Lane—Columbia, SC
James R. Latimer—Aiken, SC
Dannie E. Lee—Cheraw, SC
Michael R. Lee—West Columbia, SC
John and Jane Lester—Columbia, SC
Sara Lenehan—Laurens, SC
Leland and Katherine Lewis—Gastonia, NC
Robert Lewis—Columbia, SC
Tim Lively—Waynesboro, GA
Jean Logan—White Oak, SC
Mark Long—Columbia, SC
Ben Lovejoy—Columbia, SC
Johnnie Luchers—Dillon, SC
Press Mabry—Pawleys Island, SC
Chris Martin—Charleston, SC
Elizabeth Martin—Mauldin, SC
James Martin Jr.—Charleston, SC
Virginia Martin—Conestee, SC
Andrew Massey—Williamston, SC
Paul Matheny—Irmo, SC
Carmen Maye—Columbia, SC

Tony Maye—Wingate, NC
Harry Mays Jr.—Fair Play, SC
Kenneth McAbee – Enoree, SC
Darryl T. "Todd" McAlhany—Lexington, SC
John McCardell—Columbia, SC
John C. and Jane McCarter—Fountain Inn, SC
Frances McClary—Greeleyville, SC
Robbie McClure—Landrum, SC
James L. "Moose" Meaders—Taylors, SC
Mike Meggs—Effingham, SC
Anthony Messier—Columbia, SC
Jim Meyer Jr.—Mount Pleasant, SC
Anna Middleton—Yonges Island, SC
Dalton Miles—Lake City, SC
James E. "Ed" Miles—Spartanburg, SC
David D. Mobley Jr.—Loris, SC
Donnie Moore—Buffalo, SC
Jeffrey Moore—Gray Court, SC
James Neel Sr.—Newberry, SC
Chas H. Nicholson—Chapin, SC
Kristian Niemi—Columbia, SC
Harold L. Nobles—Columbia, SC
Al Nooft—Columbia, SC
Chris Osborne—Kingstree, SC
Charles and Kimberly Oswald—Lexington, SC
Clifton and Toni Ott—Branchville, SC
Robert Ott—North Charleston, SC
Steve and Vickie Ownby—Kodak, TN
Harry Pabst—Laurens, SC
Russ Painter—West Columbia, SC
Rusty Painter—Summerville, SC
Chip Payne—West Columbia, SC
Glenn Peacock—Columbia, SC
Allen Perkins—Westminster, SC
Patrick Perry—Rock Hill, SC
DeVeauz "Bosie" Picquet—Charleston, SC
Dave and Cathy Plowden—West Union, SC
Larry E. "Pete" Price—Andrews, SC
Scott "Scotty" Price—Columbia, SC
John B. Quinn—Charleston, SC
Tom Raines—Hilton Head, SC

Mike and Donna Ratledge—McClellanville, SC
Stephen B. Reeves—Columbia, SC
Brock J. Renkas—Charleston, SC
Robert "Bob" and Karin Renkas—Charleston, SC
William "Buddy" Reynolds—Blythewood, SC
Delbert V. Rhodes—Hope Mills, NC
Brian and Linda Rich—Charlotte, NC
Del Rivers—Columbia, SC
Delmar Rivers—Beaufort, SC
Gordon Robertson III—Charleston, SC
Marion B. Robinson—Winnsboro, SC
Bill Rogers—Columbia, SC
Walter Rolandi—Columbia, SC
Tim Roylance—Charleston, SC
Joe G. Rush—Lexington, SC
Patrick Saucier—Columbia, SC
Richard L. Schoenfeldt—Sumter, SC
Carlton Segars—Columbia, SC
Ben Senn—Laurens, SC
Reid Shepard—Greenville, SC
Clifton Simmons—West Columbia, SC
David R. Simmons—Gaffney, SC
Joey Simokat—Summerville, SC
Michael Simokat—Summerville, SC
Pam M. Singletary—Yonges Island, SC
Barrett Smith—Columbia, SC
Bronson "Bronnie" Smith—Columbia, SC
Carl R. Smith—Columbia, SC
Jamey Smith—Westminster, SC
Tommy Smith Jr.—Hampton, SC
Michael D. Snyder—Chapin, SC
Jerry and Sandy Spann—Columbia, SC
Karol Stahl—Simpsonville, SC
Mark Steele—Lancaster, SC
Walter Steele—Lancaster, SC
Chuck Stello Sr.—Moncks Corner, SC
John C. Stevens—Nakina, SC
Lina Stewart—Elgin, SC
Reese Stidham—Columbia, SC
Don Stowe—Columbia, SC
Jim Streeter—Lexington, SC

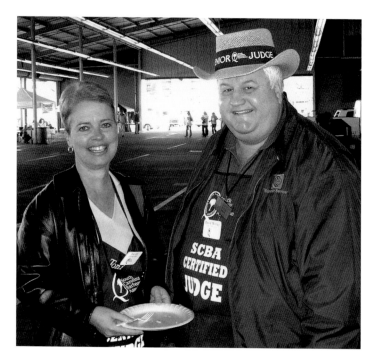

Toni Ott and David Mobley, two SCBA charter members, happy to be at the Carolina Q Cup. *Courtesy of the author.*

Joseph W. and Patsy Sutton—Lancaster, SC
David A. Tafaoa—Mauldin, SC
Ronald Taylor—North Charleston, SC
Miles C. Thomas—Greenville, SC
Jack and Sandy Thompson—Pamplico, SC
Samuel Thompson—Beech Island, SC
Michael and Pamela Toberman—Marietta, SC
Joseph Tolbert—Columbia, SC
Alvie and Denise Tompkins—North Charleston, SC
John Trafficanti—Columbia, SC
Robert Trimnal—Bishopville, SC
Jack and Mary Waiboer—North Charleston, SC
John A. Waldrop—Abbeville, SC
E.R. "Rusty" Washburn III—Spartanburg, SC
E.R. "Rusty" Washburn IV—Spartanburg, SC
Michael Watford—Lexington, SC
Travis Weed—Simpsonville, SC
Marion B. Welborn—Anderson, SC
Jim Wellman—Lexington, SC
Warner Wells—Columbia, SC
Al Werts—Leesville, SC
William W. Wheeler Jr.—Lane, SC
Harold E. Whiteley—Charleston, SC
Lee and Laura Williams—Columbia, SC
Larry and Kathy Wilson—Rock Hill, SC
Bill Woods—Ballentine, SC
Thomas York—Easley, SC
William Zeigler—Orangeburg, SC

SAUCE RECIPES

There is no sense in printing a bunch of sauce recipes here since so many are now available on the Internet and in hundreds of modern cookbooks. Plus, making your own sauce is lots of fun. Find one you like, and experiment a bit with it in your own kitchen. However, since both vinegar-and-pepper sauce and mustard sauce are historic South Carolina sauces, I've included two that have some historic interest, as well as a modern updated recipe of both.

MUSTARD SAUCE

The recipe for the barbeque sauce that is reproduced below is the first such recipe that, so far, has been uncovered by various historians. This recipe is taken from the 1872 edition of Mrs. Hill's book, which was first published in 1869. Note that even though this is a Georgia recipe, it is a mustard-based sauce. Remember that ketchup as we know it, while invented in the early 1800s, did not become widely available until after 1890, so red barbeque sauces were not in existence in 1869. Since there is no sugar in this recipe, it can be used as a basting sauce as well as a finishing sauce. When you think about it, a barbeque sauce was reasonably simple to make. All you had to do was take the basic vinegar-and-pepper sauce and add a condiment - mustard - that contained some mixture of the basic mustard and some

other spices. The same can be said of the light tomato sauce that is loved in the lowcountry of South Carolina and North Carolina. Just take the basic vinegar-and-pepper basting sauce and add ketchup and maybe a bit of sugar or molasses, and you have a light tomato barbeque sauce.

SAUCE FOR BARBECUES

Melt half a pound of butter; stir into it a large tablespoonful of mustard, half a teaspoon of red pepper, one of black, salt to taste; add vinegar until the sauce has a strong acid taste. The quantity of vinegar will depend upon the strength of it. As soon as the meat becomes hot, begin to baste and continue basting frequently until it is done; pour over the meat any sauce that remains.

VINEGAR-AND-PEPPER SAUCE

The earliest vinegar-and-pepper basting sauce is so old that its beginnings are lost in time, but since it is so simple, it has been handed down by word of mouth for centuries. This simple recipe lends itself to variations of vinegar (I like a mixture of equal parts white vinegar and red-wine vinegar) and peppers.

VINEGAR AND PEPPER SAUCE FOR BASTING BARBEQUE

Into a quart of vinegar, put one tablespoon of red pepper flakes and one tablespoon of black pepper. Add salt to taste, but no less than one tablespoon.

Below is another one of my friend Craig Goldwyn's kitchen-tested recipes. He comments that he loves a good vinegar-and-pepper sauce on whole hog, and while he named this recipe "East Carolina Mop Sauce," on his website he also points out that it is the same as the "low-country sauce" found in South Carolina.

East Carolina Mop Sauce

Yield: about 1½ cups
Preparation time: about thirty minutes

Ingredients

1½ cups of distilled vinegar
1 teaspoon hot sauce
2 tablespoons sugar (white, light brown or dark brown)
1 tablespoon salt
2 teaspoons crushed red pepper
2 teaspoons finely ground black pepper

About the vinegar: It seems to me that the best sauces in the area were made with distilled white vinegar, not cider vinegar. So I tried my recipes with both, and I liked the distilled better. If you want to use cider, feel free.

Method:

1. Pour all the ingredients into a jar and shake. Let it sit for at least twelve hours to allow the flavors to meld. A week is better.

2. You can use this sauce as a mop sauce when you cook and/or as a finishing sauce when you serve the meat. In the Carolinas, it is usually used as both a mop and a finishing sauce.

3. To use it as both a mop and finishing sauce, warm it, pour a few ounces into a cup and paint it on the meat with a basting brush once every hour or so while it is cooking. If you use it as a mop, the sauce in the cup can get contaminated with uncooked meat juices on the brush. That's why you don't want to dip the brush in the whole bottle. Discard contaminated mop and serve untouched sauce at the table.

REFERENCES

BBQ Digest. *The Palmetto State Glove Box Guide to Bar-B-Que*. Marietta, GA: Longstreet Press, 1997.

Caldwell, Wilber W. *Searching for the Dixie Barbecue: Journeys into the Southern Psyche*. Sarasota, FL: Pineapple Press, 2005.

Craig, H. Kent. *Kent's Carolina Barbecue Book: Carolina Barbecue Restaurant Reviews, Recipes, History, Culture, More*. Charleston, SC: CreateSpace, 2010.

Edgar, Walter. *South Carolina: A History*. Columbia: University of South Carolina Press, 1998.

Garner, Bob. *North Carolina Barbecue: Flavored by Time*. Winston-Salem, NC: John F. Blair, 1996.

Hill, Annabella P. *Mrs. Hill's Southern Practical Cookery and Receipt Book*. Columbia: University of South Carolina Press, 1995.

Hudson, Charles. *The Juan Pardo Expeditions: Explorations of the Carolinas and Tennessee, 1566–1568*. Tuscaloosa: University of Alabama Press, 1990.

Hudson, Charles, and Carmen Chaves Tesser. *The Forgotten Centuries: Indians and Europeans in the American South, 1521–1704*. Athens: University of Georgia Press, 1994.

Jones, Katharine M. *Port Royal Under Six Flags*. Indianapolis, NY: The Bobbs-Merrill Company Inc., 1960.

Kibler, Juanita C. *Dutch Fork Cookery: A Treasury of Traditional Recipes from the German Kitchens of Central South Carolina*. Athens, GA: Dutch Fork Press, 1989.

Lorant, Stefan. *The New World: The First Pictures of America: Made by John White and Jacques le Moyne and Engraved by Theodore De Bry*. New York: Duell, Sloan & Pearce, 1946.

Mauncy, Albert. *Florida's Menendez: Captain General of the Ocean Sea*. St. Augustine, FL: The St. Augustine Historical Society, 1965.

Moore, John Hammond. *Columbia and Richland County: A South Carolina Community, 1740–1990*. Columbia: University of South Carolina Press, 1993.

Moss, Robert F. *Barbecue: The History of an American Institution*. Tuscaloosa: University of Alabama Press, 2010.

Reed, John Shelton, Dale Volberg Reed, and William McKinney. *Holy Smoke: The Big Book of North Carolina Barbecue*. Chapel Hill: University of North Carolina Press, 2008.

Rutledge, Sarah. *The Carolina Housewife: A Facsimile of the 1847 Edition*. Columbia: University of South Carolina Press, 1979.

Smith, Andrew F. *Pure Ketchup: A History of America's National Condiment*. Columbia: University of South Carolina Press, 1996.

South, Stanley. *Archaeology at Santa Elena: Doorway to the Past*. Columbia: University of South Carolina Press, 1991.

Wall, Allie Patricia, and Ron L. Layne. *Hog Heaven: A Guide to South Carolina Barbecue*. Lexington, SC: The Sandlapper Store Inc., 1979.

Warnes, Andrew. *Savage Barbecue: Race, Culture, and the Invention of America's First Food*. Athens: University of Georgia Press, 2008.

INDEX

ABOUT THE AUTHOR

Lake E. High Jr. was born in Columbia, South Carolina, and except for a few years spent working in Washington, D.C., he has lived there all of his life. One of his earliest childhood memories is holding his father's hand and being taken to Lever's Barbeque restaurant, which was then located in West Columbia. He loved it.

High worked as a stockbroker most of his life, but after he first graduated from the University of South Carolina with a degree in political science, he worked for several years in the public-relations section of the South Carolina Electric Cooperatives Association. While traveling around the state, he never missed a barbeque house. By the time he was in his late twenties, friends were urging him to write a book on South Carolina barbeque, since he had probably eaten in more barbeque restaurants than anyone in the state.

Before his venture into the field of judging barbeque, High was an American Wine Society certified wine judge, and those twenty years of experience gave him some background in tasting and judging that he found helpful when it came time to teach others how to judge barbeque. In 2004, he and Dr. Walter Rolandi founded the South Carolina Barbeque Association (SCBA) with the object to train other barbeque judges and help towns and organizations put on local barbeque festivals. In the last nine years, they have trained over seven hundred barbeque judges and have helped start over thirty-five different barbeque cook-offs.

High now serves as the president of the SCBA and is an SCBA Master Barbeque Judge, and he is always looking forward to his next plate of 'que.